Animation
a Handy Guide

This book is dedicated with thanks to
Lucy D. Burroughs, teacher extraordinaire
who showed me in 1961 at Birmingham School for Training Art Teachers
that "everyone is an artist ".

First published in 2009 by A & C Black Publishers Ltd.,
36 Soho Square, London W1D 3QY
www.acblack.com

ISBN 978-1-408-10283-1

Commissioning Editor: Susan James
Managing Editor: Sophie Page
Copy Editor: Julian Beecroft
Designed and typeset by Fluke Art, Cornwall
Cover designed by James Watson

This book is produced using paper that is made from wood grown
in managed, sustainable forests. It is natural, renewable and
recyclable. The logging and manufacturing processes conform to the
environmental regulations of the country of origin.

Printed and bound in China by C&C Offset Printing Company Ltd.

The rotoscoped photographs are of Sheila Graber from 1940 to 2008

Animation
a Handy Guide

by *Sheila Graber*

What's In

What's More

Animation is the art of creating life where none existed before. As it is movement that makes animation, I felt it vital that the moving image was combined in some way with the text and images of the book. So, this book is simply the 'front end' to a matching DVD intended to be used on PC or Mac computers alongside the book itself.

In it, all key pages are re-created interactively with the addition of QuickTime movies and many hyperlinks to relevant web pages. By using the web links you will view most historical items mentioned in their original form. You can also find an extensive further reading list on the DVD.

Animation is fun, so this book is aimed not only at professionals but also students and total beginners who have always fancied having a go at this magic art. It must be stressed that all points covered on the creation of animation, from pastel to Plasticine and from film cameras to digital cameras, are relevant to the use of current computer programs. Some specific ideas for animating on computers are covered on the DVD – plus a digital 'flick book' to allow you to start animating straight away!

A key web link is **www.graber-miller.com** where you will find more information about the author.

Most images used in the book and DVD have been created, or in some cases re-created, by Sheila Graber or University of Sunderland students and are their sole copyright 2009.

What's What? 20 Key Sections in detail

Thinks

"Never never never give up"

Winston Churchill and
my mother Doris Graber,
both born Nov. 30th.

My Mother and I, 1940.

The writing of this book was
made possible by my appointment
as Senior Teaching and Research Fellow
at the University of Sunderland.

Being made a 'senior' reminded me that I am getting on a bit and
maybe it was time to set down in words, stills and moving images, a
summary of my personal experiences in art, animation and teaching
over the past 60 years, in the hope that some of it might be of use to
others wishing to explore the magical art of animation.

My Mother and I, 1980.

'Begin at the beginning, go on to the end and then stop.'
Lewis Caroll, *Alice through the Looking Glass*

Thanks

I would like to thank all the following people for their contribution to this book and DVD:

Professor Flavia Swann and her team at the School of Arts, Design, Media & Culture at the University of Sunderland, for inviting me to write this book, especially Melanie Hani, Martin Hillman and Ros Allen, whose animation students have kindly provided critical clips; Neil Ewins, who helped extend all content into the wider world of design; Valerie Cornell, for patiently proof-reading every page; Mike Pickard, for help with Director; Dr Manny Ling, Keith Robson and Andrew Barker, for technical support throughout the whole production process; Professor Brian Thompson, Shirley Wheeler and Gurpreet Singh, for their positive advice and encouragement, which was essential to the completion of this work; Andy Laverick, 3D CGI animator, for his expert help; Ben de Vere Weschke, for the statement about his mother Alison; Ian Sachs, for his professional advice on working in studios; Brenda Orwin and Josephine Halbert, for helping me evolve my animation horizons;

Students from the University of Sunderland course in Animation, who have provided both still images and animated movie clips from their work. Annabelle Hoggard – a 3D walk cycle, and the last part of the CGI chapter; Kam-Li Cheng – *Vinnie Versus the Fly*, *The Highwayman* and *Avatara*; Li Ak Jan (Jenny) – *Puppet Master*; Joanne Heslop and Lyndsey Warnett – *Out to Play*; James Uttley, Sarah Thompson, Sixue Wu (Icer) and John Whitehead – *Four Seasons*; Stephen Archibald, Arran Cartie, and Mathew Bingham – *Yankee Doodle*; Jurate Gecaite, Daniel McCloskey, Alex Giblin and Jennifer Lister – *3 Little Pigs*; Sarah Thompson – *Pixillation Exercise*; Sarah Boyle, Adele Paterson, Sarah Imrie and Helia Kasiri – *The Lost Cat*; Jardine Sage, Lucie Short and Ahovi Sule – *Dali*; Angela Richards, Stephanie Richards, Sean Normansell and Lucie Short – *Scribble Tuesday*;

My cousin Jane Stobart, lecturer and printmaker, for checking on animation content and reminding me to keep this book wide in scope and fun to read; Grace Murphy, aged 8, for stills and a movie made on her mobile phone.

David Williams, for advising on the historical backbone around which all revolves. He has been an avid fan of animation since childhood, and set up one of the first film study courses in the UK. David's ideas have provided a pattern for others, and he has organised major animation-art exhibitions on British animation, Lotte Reiniger, *Snow White* and *Fantasia*. Given rare access to Disney Archives in the US he has delivered papers on animation history to world audiences. **Richard Welsh**, for creating the backbone of interactivity for the DVD. Introduced to programming software at the age of 8 by me, he began building basic games just for fun. The making of those games motivated him to learn more about programming, eventually leading to a degree in computer science and a job as a professional games developer. **Jen Miller,** fellow company director, for providing most of the live-action photography throughout the book, and also for wisely suggesting I take semi-retirement, thereby making the production of the whole project possible. Special thanks to my copy editor, Julian Beecroft, who went above and beyond the call of duty in suggesting re-writes for some key sections of the book so they now read clearly and with much greater depth. Most importantly of all my thanks go to Susan James who had enough faith in my 'off the wall' concept to encourage publication. Also to Sophie Page who took up the baton and challenge to skillfully guide it through to completion. And last but not least, Dixi who helped by pressing the 'paws' button.

Foreword
by Professor Paul Wells

Professor Paul Wells is Director of the Animation Academy in the School of Art & Design, Loughborough University.

He has published widely in the field including *Understanding Animation* (Routledge 1998); *Animation and America* (Rutgers University Press) and *Fundamentals of Animation* (AVA 2006). He has also made a Channel Four documentary called *Cartoons Kick Ass* and three BBC programmes on British Animation. He is often called upon to select programmes of animation for various festivals across the world.

What do we think of when we say the word 'animation'?

Walt Disney. Saturday-morning cartoons. The Simpsons. The Incredibles. Norman McLaren. Bugs Bunny. Akira. Wallace and Gromit. Lotte Reiniger. Animal Farm. South Park. Yuri Norstein. Chuck Jones. Jurassic Park. Bob the Builder. The list becomes endless…

It encompasses drawn animation, Cel animation, 3D stop-motion animation, computer animation, all manner of approaches drawn from the fine arts and graphic design, and all contemporary digital practices, conflating traditional animation and visual effects. Where once upon a time, animation was the neglected second cousin of mainstream live action film practice, it is now the fundamental language of cinema itself.

Animation is everywhere. At the multiplex, on TV, on the web, on hoardings and displays, on mobile phones and palm pilots, in computer games, in the gallery and museum, in medical imaging and architectural design, and in every multi-media presentation and exhibition.

One small problem. While all manner of disciplines have 'converged' and found a common language, the cultures that represent them have not. That is the next task – one of bringing communities of interest, passion, investment and creative skill together. It is not a new task. It is one that has been performed on many occasions in relation to many social and ideological changes – it is one that has always been at the heart of those who have taught animation, and sought to use it as a profoundly effective educational tool in the service of bringing people together and engaging them with art. It is a task that has been performed throughout the long and distinguished career of Sheila Graber.

When I first met Sheila, I was inspired, as many people have been, to drop pen and paper, and make an animated film. Granted, my adventures involving a small button, three matches, and half a Dinky-toy – mainly chases back and forth across a picture of an idyllic English landscape torn off a cereal packet - were no match for the Disney output, but you have to start somewhere. Sheila has enabled so many people 'to start somewhere' and to go on a life-long journey embracing the art and culture of animation.

Her ceaseless energy and talent – both in her own film-making and teaching – have had a profound influence, and like many British animators, she remains an unsung heroine of the form. Here is a place at least, to start singing…

This book represents Sheila's clear and engaging view of the animated form, and ways to become involved with its history and practice. Use it, enjoy it, see it as the start of something important.

To animate is to give life to something. Animation is something Sheila has given her life to. Here she gives animation back to you once more.

Professor Paul Wells

Forewarning
by David Sproxton

Aardman Animation was co-founded in 1972 by David Sproxton and Peter Lord and is now an internationally renowned animation company.

There follows an extract from a personal reply from David Sproxton in which I asked him what was the real story behind the success of Nick Park's work.

The question you raise is one of interest, as there is a sense amongst students that they will find instant fame and fortune and they do not understand what they are up against at all! I don't think there is a very good understanding of the development process, taking an idea through to production, and how long that takes and what it costs.

We met Nick Park in the early 1980s when he was at the National Film School in Beaconsfield. Pete and I had been asked to do a day's workshop at the school even though we hardly knew what we were doing ourselves at the time! Nick was at work on his college film *A Grand Day Out* and was in his last year of three. He signed on for another two years to finish it. During the summer we employed Nick to help us shoot Morph material for the BBC. Eventually we said to Nick he should join us to help us make a 15-minute film for Channel Four (Babylon) which featured about 50 characters. The deal was we would help him finish his film. He joined us in 1985. After completion of both films we got a commission from Channel 4 to make a series of five-minute films based on real soundtracks. Nick decided to use animals in a zoo – *Creature Comforts* went on to win an Oscar in 1989.

There is no doubt that success helps breed success in this business. The TV stations know their audience and know a good idea when they see one. It's important to work with them rather than against them. If they want the idea to feature a boy and a girl rather than two boys then rewrite it that way. The chances are it will work better.

From our own standpoint, we'd prefer to see from candidates a small number of short films, or even ideas, rather than some great lumbering work which they've slaved over for years. Most animators are not brilliant writers and although they may come up with some great characters and set-ups we wouldn't expect them to write a whole series unaided. We will find writers to collaborate with them. So students shouldn't feel concerned that they can't fulfil all the roles needed: we wouldn't expect it and there are other people out there who are brilliant at filling those creative gaps, although they may be lousy animators or directors.

In terms of developing ideas, we'd reckon it takes at least a year to get a TV series idea up to the point of commission from initial idea and for a feature film there will be two to three years of development before the film goes into production. This will include design, of course, but the bulk of this time is spent getting the story right! Production will take about 15 to 18 months so the whole cycle takes about five years. This is little understood, I sense, but should be stressed to give people an idea of the amount of intellectual effort put into writing (using a small team) before production begins in earnest.

Hope this helps!

David Sproxton

Top 20 Key events in animation history linked

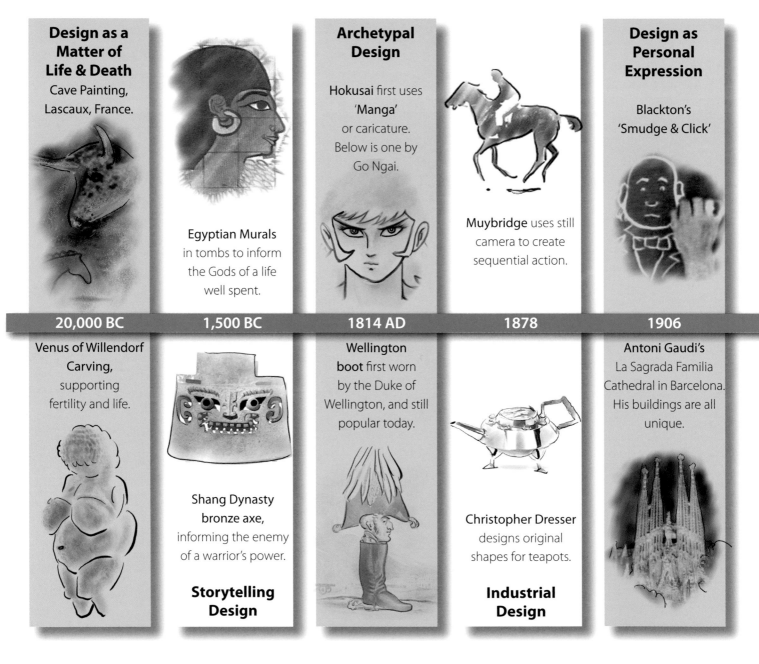

Design as a Matter of Life & Death
Cave Painting, Lascaux, France.

Egyptian Murals
in tombs to inform the Gods of a life well spent.

Archetypal Design

Hokusai first uses 'Manga' or caricature. Below is one by Go Ngai.

Muybridge uses still camera to create sequential action.

Design as Personal Expression

Blackton's 'Smudge & Click'

| 20,000 BC | 1,500 BC | 1814 AD | 1878 | 1906 |

Venus of Willendorf Carving,
supporting fertility and life.

Shang Dynasty bronze axe,
informing the enemy of a warrior's power.

Storytelling Design

Wellington boot first worn by the Duke of Wellington, and still popular today.

Christopher Dresser designs original shapes for teapots.

Industrial Design

Antoni Gaudi's La Sagrada Familia Cathedral in Barcelona. His buildings are all unique.

to 20 in the wider world of design

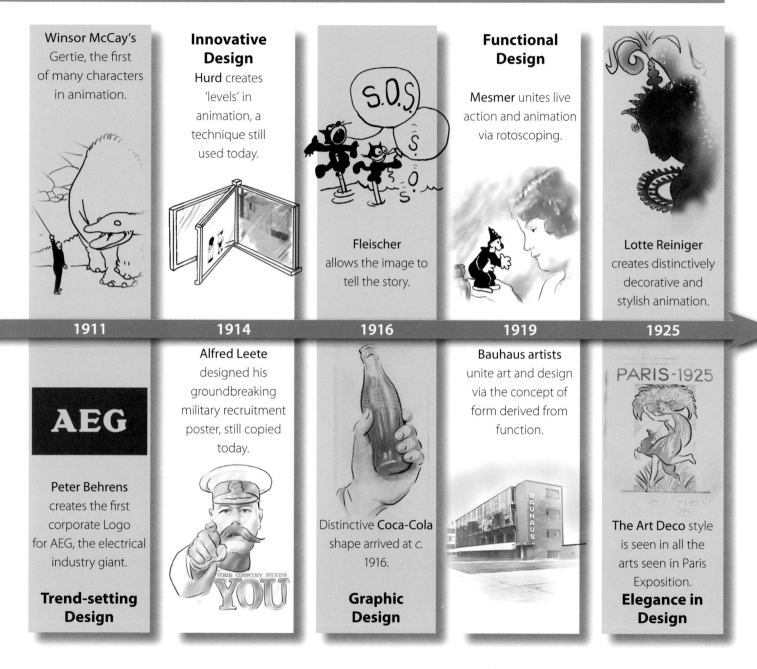

Winsor McCay's Gertie, the first of many characters in animation.

Innovative Design

Hurd creates 'levels' in animation, a technique still used today.

Fleischer allows the image to tell the story.

Functional Design

Mesmer unites live action and animation via rotoscoping.

Lotte Reiniger creates distinctively decorative and stylish animation.

1911　　**1914**　　**1916**　　**1919**　　**1925**

Peter Behrens creates the first corporate Logo for AEG, the electrical industry giant.

Trend-setting Design

Alfred Leete designed his groundbreaking military recruitment poster, still copied today.

Distinctive **Coca-Cola** shape arrived at *c.* 1916.

Graphic Design

Bauhaus artists unite art and design via the concept of form derived from function.

The Art Deco style is seen in all the arts seen in Paris Exposition.

Elegance in Design

Top 20 Key events in animation history linked

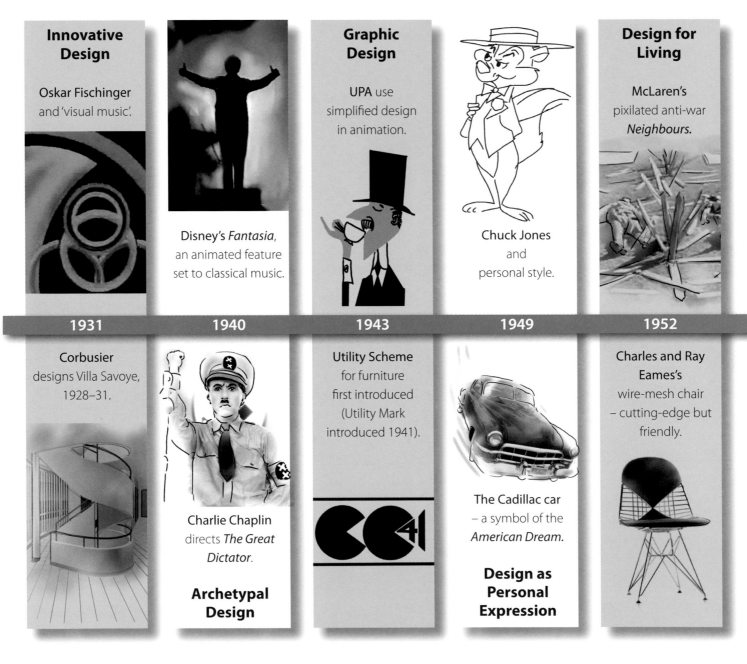

Innovative Design

Oskar Fischinger and 'visual music'.

Disney's *Fantasia*, an animated feature set to classical music.

Graphic Design

UPA use simplified design in animation.

Chuck Jones and personal style.

Design for Living

McLaren's pixilated anti-war *Neighbours*.

| 1931 | 1940 | 1943 | 1949 | 1952 |

Corbusier designs Villa Savoye, 1928–31.

Charlie Chaplin directs *The Great Dictator*.

Archetypal Design

Utility Scheme for furniture first introduced (Utility Mark introduced 1941).

The Cadillac car – a symbol of the *American Dream*.

Design as Personal Expression

Charles and Ray Eames's wire-mesh chair – cutting-edge but friendly.

to 20 in the wider world of design

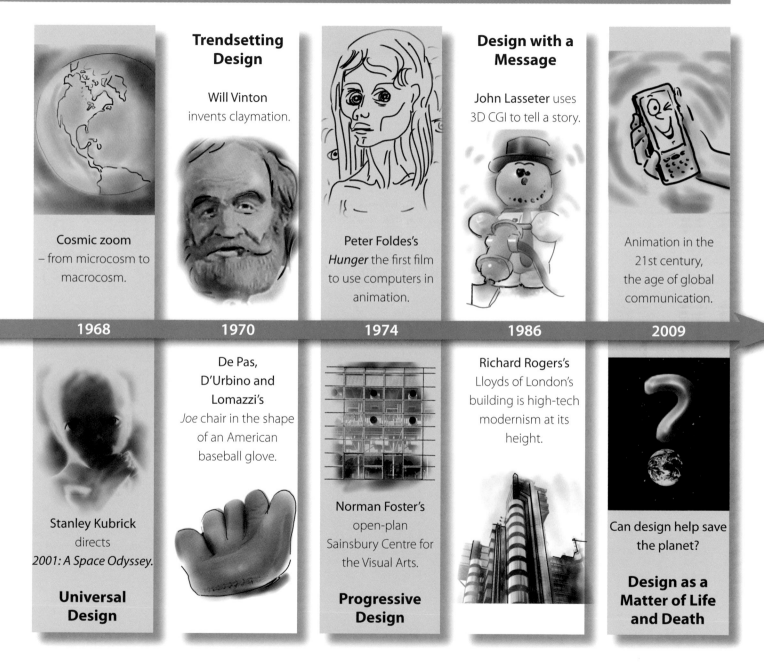

Trendsetting Design

Will Vinton invents claymation.

Design with a Message

John Lasseter uses 3D CGI to tell a story.

Cosmic zoom – from microcosm to macrocosm.

Peter Foldes's *Hunger* the first film to use computers in animation.

Animation in the 21st century, the age of global communication.

1968 **1970** **1974** **1986** **2009**

Stanley Kubrick directs *2001: A Space Odyssey.*

Universal Design

De Pas, D'Urbino and Lomazzi's *Joe* chair in the shape of an American baseball glove.

Norman Foster's open-plan Sainsbury Centre for the Visual Arts.

Progressive Design

Richard Rogers's Lloyds of London's building is high-tech modernism at its height.

Can design help save the planet?

Design as a Matter of Life and Death

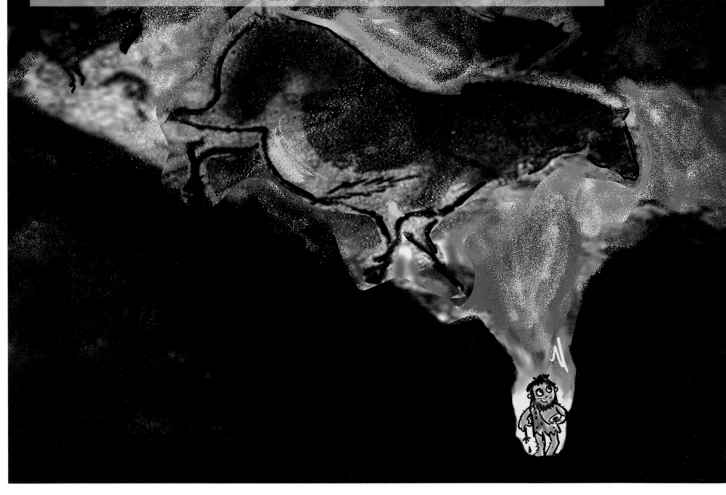

Art as a Matter of Life and Death

'The earliest work of an artist is cave painting. From this evolved sculpture, writing, mime and dance. All these arts are brought together once more in modern animation.'

The Technique of Film Animation
John Halas, Halas & Batchelor Animation Studios

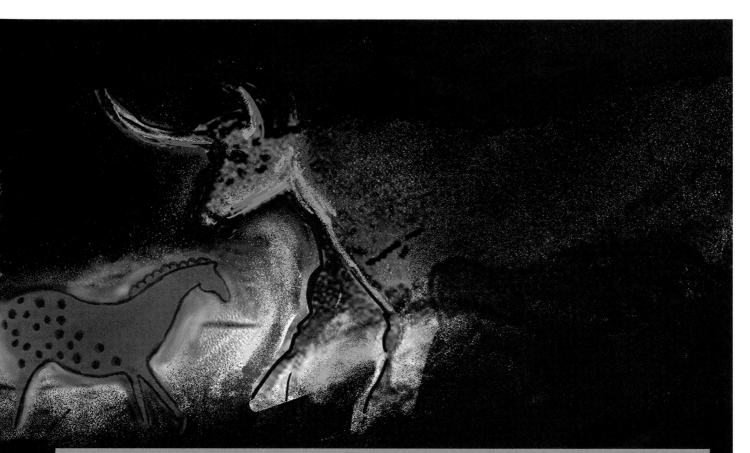

20,000 BC Cave Painting

No one knows for sure why people scraped oxides from the earth, mixed them with blood – hopefully not their own – and applied them in the shape of animals onto dark cave walls in flickering firelight. As just staying alive was pretty tough it can't have been to cover up cracks on the wall or to brighten up the dining room.

So why did they do it?
It had to be linked to survival, as all the animals depicted could be eaten for food (there are no sabre-toothed tigers). Could it be that by re-creating an image of the hunted animal they felt they had power over it and maybe could control it in real life? If you're thinking that it's old fashioned to feel an image could possibly have any power over what it depicts, consider poking the eyes out of a photo of your best friend. Mmmm. Maybe think again?

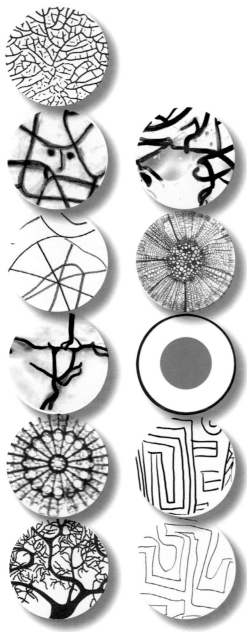

Look at the 11 circular images.
Are they 'art' or not ?
Identification on DVD.

What is Art?

In 1961, I and a few other students from Sunderland Art College (as it was then) went on to take a Teacher Training Certificate at Birmingham School for Training Art Teachers – thirty of us chatting and gasping for a smoke, waiting for our first lecture to start.

In walked Lucy Burroughs, a tall grey-haired figure. She stood upright and stock still, and we slowly stopped chatting or thinking about smoking. Eventually, after what seemed an age, she asked in a slow resonant voice, **'Why are you here?'** Silence, then some joker spoke up, 'To get our Art Teacher's Diploma'. **'So what is Art?'** Lucy bounced back... and then left us to work out an answer for ourselves.

In that year we were guided through some answers – not only visiting schools from nursery to tertiary, but also the noisy, monotonous production lines on which many of the children taught in those schools would work for most of their lives.

Lucy and her highly animated team showed us that everyone is an artist, that everyone needs to be able to succeed and express themselves in some way, and it was our job as teachers to provide an environment in which every individual could take what they needed at their own level.

This was, to me, a eureka moment, a life-changing event. So art teaching could be creative in itself! George Bernard Shaw's famous aphorism, 'Those who can, do; those who cannot, teach', need not be so. Armed with the knowledge given to me that year, I've gone on following that star for the rest of my life. In the process I've discovered that, as William Blake said, 'Energy is eternal delight'. Whether you use that energy to create or destroy, it's the same energy. The practice of art can turn a person from a vandal to a builder!

What's your star? What's your dream? Now is the time to follow it. If you focus and set your mind to it, it can happen.

Lisa Smith was a Fine Art student at the University of Sunderland up to her early death from Leukaemia in 1997, aged 27. Knowing death was imminent she focused clearly on what was important to her – which turns out to be of equal importance to us all.

Crisis Point, December 1996
PLAN: Build a clearer picture of myself and how I feel ... In some way use the OBJECTS about me as a SELF-PORTRAIT. Research from the hospital intensive care unit – e.g. tubes, syringes – incorporating hands, legs, chest etc., as well as mechanical objects.

Extract from one of Lisa's many sketchbooks.

Go for It was completed on Lisa's deathbed. This highly positive, strongly graphic book has been translated into four languages and has helped countless people live a normal life despite having haemophilia.

Virginia Bodman was Lisa's Fine Art tutor. She herself always uses sketches to 'build up a larder of things that the paintings draw on'. Here in *Mary Crook's Mead*, she is dealing with growing children and a dying parent. Significantly, she gravitates to the 'impermanent places, the river and the places between the tides'.

Painting and animation share many pictorial concerns – although their use of time and presence is very different; working in both media gave Lisa Smith the opportunity to explore her acute awareness of time and presence in different ways. Lisa loved oil paint and the rich and complex forms that it can make; her paintings, made in layers, are accumulations of her time and her very particular personal experience and are a gift of time and self to those who have longer to enjoy them.

Virginia Bodman, 2008

The background to this double page is a detail from a painting by Lisa showing the 'X' factor that contributed to her fatal illness.

2 Storyboarding

1,500 BC Egyptian Tomb Murals

The job title given to an artist in Egypt was 'One who keeps alive'. Thus murals on tomb walls had to be very clear to the viewer – in their case, the gods.

In his tomb at Thebes we see Sennoter, the Keeper of the Royal Gardens, sniffing a lotus symbol of rebirth. His less important sister is hugging his knees. Maybe this is where the concept of a 'Big Brother' first began!

If the story was drawn clearly then there was a good chance that the dead person would make it into the fun-filled afterlife. Not unlike an animator and client – if you can make your idea clear to the person paying you, then you may just get the job!

Artists always squared up their work to ensure clarity and continuity. Images rarely changed for thousands of years. Originality was neither needed nor encouraged.

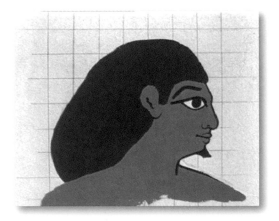

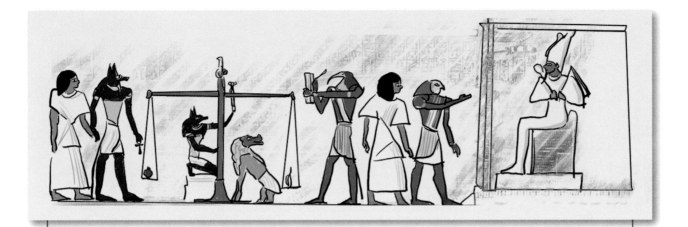

 Look carefully at the above mural and see if you can work out what the story is. Names of gods etc. are not important. Don't cheat, look first, then read on...

 Anubis, the Jackal-headed god, leads in the deceased and then weighs his heart against the feather of truth. Ammut waits to devour the heart if it's not up to scratch. Bird-headed Thoth records the verdict. All OK, so Horus (another bird brain) presents our hero to Osiris, the top Man.

If you got the overall action right it's due to three main elements.

1. All characters and objects are drawn from the clearest angles – head in profile, eyes in front, body from front, legs in profile.

2. The action is laid out in a simple format in which only relevant images and colours are used. No extra decorative details to confuse the storyline.

3. You are a very good observer!

A storyboard can have a number of different functions. It can serve to clarify ideas to animators themselves; it can help explain the project to a client, encouraging them to back an idea; and it can serve as a visual guide to a group involved in a project.

1 Clarifying the idea to the animator themselves.

As an independent animator this, for me, is the most important use of all. If you aren't clear in your own mind about what it is you're after, then you just cannot animate it with any true conviction or clarity.

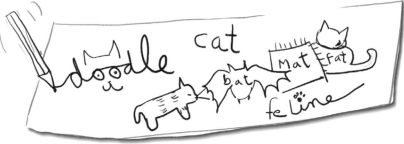

Say you want to animate the word 'cat'. Start by doodling and jotting down anything you can think of about 'cat'. Explore every avenue: look at books, the Web, real cats. Saturate yourself with information.

Relax and simmer for a while.

In fact, leave the project and do something completely different. Have a bath or take the dog, or cat, for a walk. The main thing is you forget about the whole thing for a while. It may take an hour, a day or even longer, but you can be sure that your brain will link formerly separate ideas to form a new concept. This is your eureka moment and it is a trick that has helped me create thousands of different ideas over the years. A simple formula, which you can apply to your own work, is:-

1. Question or Aim	2. Saturation	3. Simmer	4. Eureka	5. Make it!

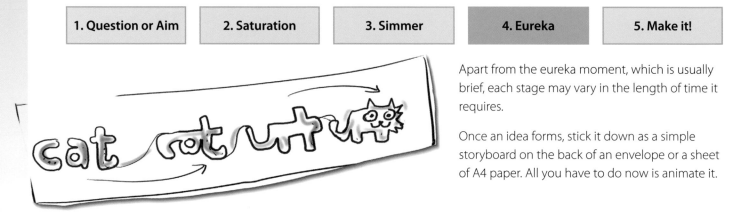

Apart from the eureka moment, which is usually brief, each stage may vary in the length of time it requires.

Once an idea forms, stick it down as a simple storyboard on the back of an envelope or a sheet of A4 paper. All you have to do now is animate it.

THE HENLEY COLLEGE LIBRARY

2 Explaining the continuity of a story to a sponsor or client.

Once you have drawn the rough storyboard, a complete presentation including other elements such as text or soundtrack can be smartly presented to a client. A storyline can be made clearer by the addition of text, or by music and narration if using an animatic presentation – that is still images cut to a guiding soundtrack.

Scene opens with text 'walking' on.

The lettering gradually changes over two seconds.

A cat is formed which walks along centre screen.

3 Serving as a visual guide to a group involved in a production.

Walt Disney in action at a Pinocchio storyboard conference circa 1939. The images are pinned to the wall to enable them to be shifted about to tell the story more clearly. Such a meeting not only inspired his team, but also enabled them to get an overview of the project and their particular part in it. Such clarity is vital, as all the fragments created must eventually fit together as a whole.

List the various skills needed, then plan your group's work around them – for example, character designer, background artist, special FX, musician, narrator.

In 2004 I was commissioned to make an animated film about cargo on the River Tyne. I was free to choose how I did it while at the same time getting paid for it – a very rare event! However, when you are not working to a tight brief, it can be hard. You have so much freedom it is sometimes difficult to home in on one concept that will work as a complete movie.

There follows a storyboard of events that led to the making of *Tyne Cargo*.

1

My Dad was Pilot Master. I grew up by and on the river.

2

I drew, painted and animated Tyne life from the age of 11.

3
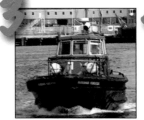
At 64 I received this commission and so re-visited the river.

4

I explored it through films, drawings, and interviews.

5

Museum keepers helped with the past and present.

6

Animating with dockers helped clarify present and future.

7
After six months my eureka moment arrived. Linking cargo with tidal movements in and out of the river, I planned my personal storyboard.

8

9

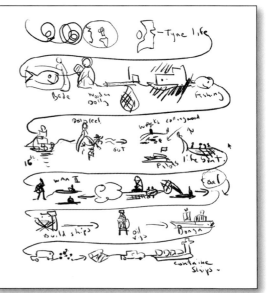

With the concept clear in my head I could go on to make a storyboard for the client and then make the movie.

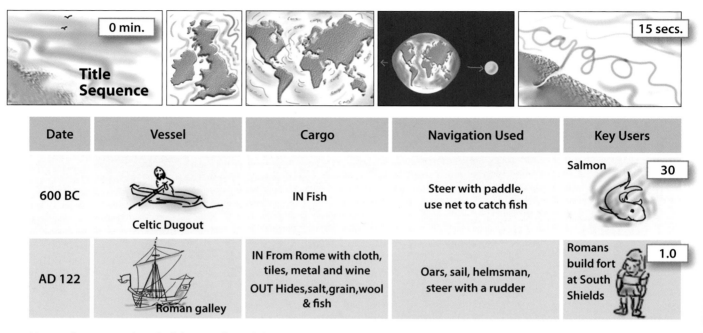

Date	Vessel	Cargo	Navigation Used	Key Users	
600 BC	Celtic Dugout	IN Fish	Steer with paddle, use net to catch fish	Salmon	30
AD 122	Roman galley	IN From Rome with cloth, tiles, metal and wine OUT Hides,salt,grain,wool & fish	Oars, sail, helmsman, steer with a rudder	Romans build fort at South Shields	1.0

Here is the start and end of the storyboard designed to show the key stages of the animation to the client, the Port of Tyne Authority and John Hudson the musician on the project. Timings are given in blue framed boxes for the musician to work to. For example, the title sequence runs from 0 to 15 seconds and requires slow rhythmic 'breathing' sounds as the tides move in and out around the planet just as cargo goes in and out of ports.

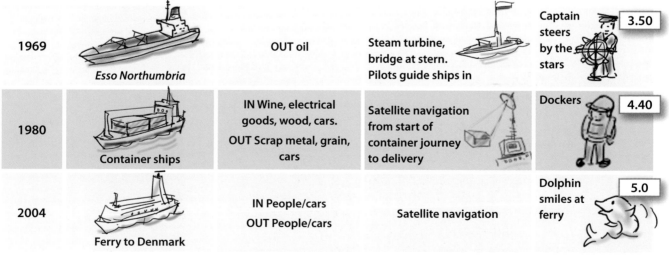

Date	Vessel	Cargo	Navigation Used	Key Users	
1969	Esso Northumbria	OUT oil	Steam turbine, bridge at stern. Pilots guide ships in	Captain steers by the stars	3.50
1980	Container ships	IN Wine, electrical goods, wood, cars. OUT Scrap metal, grain, cars	Satellite navigation from start of container journey to delivery	Dockers	4.40
2004	Ferry to Denmark	IN People/cars OUT People/cars	Satellite navigation	Dolphin smiles at ferry	5.0

3 Archetypes

Many images used in 21st-century animation have their roots in the distant past. It can be very interesting to track back the original concept or archetype to see where others have been and where you might go.

The Japanese artist Hokusai 1760–1849 first used the term **'Manga'** which means 'whimsical drawings'. His print *The Great Wave off Kanayawa* led to a flood of Manga comics and movies.

Q Which of the above baby faces do you think is cute? Why ?

A *The theory goes that it is the one with the big round eyes, set well apart in the centre of a little round face – the archetypal 'baby face' is the most appealing. These proportions evidently appeal to human adults, and thus this baby is more likely to be loved and cared for by all who see it. Babies with narrow eyes set high up in a tapering face must have a hard time!*

The Thunderbird that features in the ancient myths of Native American tribes was first noted by westerners in the 18th century, and was a symbol of cosmic power and energy. Its spirit lives on in many animation series and also, of course, in motor cars.

Go Ngai drew this 'Devilman' in 1972, one of the first Manga heroes to be animated.

Cuties from the original 1902 Teddy Bear to Pikachoo use the baby-face theory.

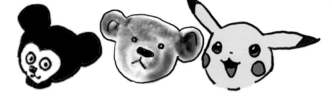

Spot the Goth. *One is from the 12th-century Gothic Cathedral at Chartres, while the other is not!*

Heidi's Horse

Sylvia Fein tracked the natural growth of one child's drawing. The age of each stage may vary but the development is the same for us all.

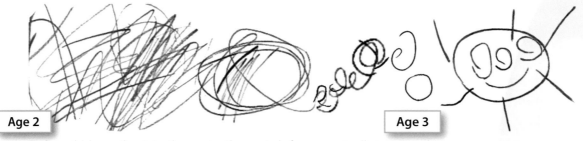

Age 2

Age 3

Early scribbles gather into the centre then spirals form eventually into a circle. Straight lines and circles will draw anything from a sun to a face.

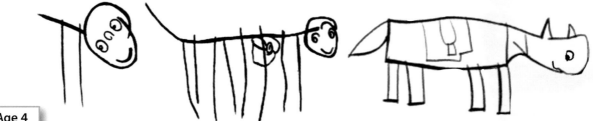

Age 4

A short line gets two legs, while longer lines get eight; balance matters, correctness to reality does not! Finally she arrives at four.

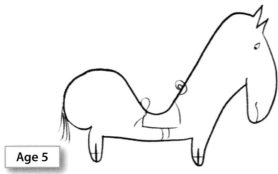

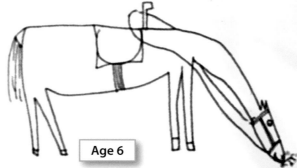

Age 5

Age 6

Eventually one continuous line draws the body, and after observation of a real horse the head is lowered 'so he can eat'.

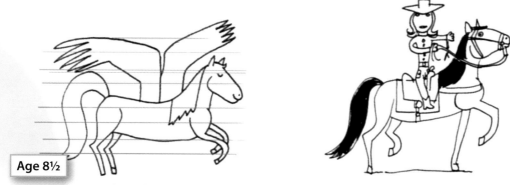

Age 8½

The horse in her school book shows 'gravity'. After riding lessons the right tack, and the rider herself can be drawn.

Age 9

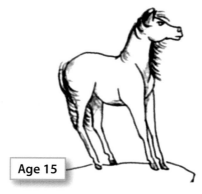

Age 15

Overlapping is explored, as are her emotions.

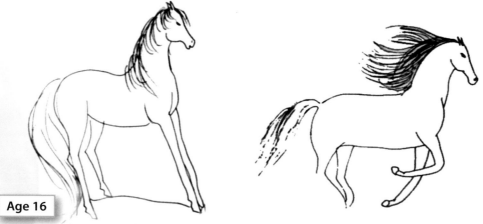

Age 16

Heidi's horse is ready to leap out into the world – tall, stylish, just like her!

EXPRESSIONISM

Having spent two months glued to the light box animating elephants for a TV series on Kipling's *The Just So Stories*, I emerged into the daylight to visit a Munch exhibition at a local museum.

Knocked out by the imagery, I rushed home to start animating *Expressionism*, in which I wanted to show that if you wish to express any emotion you have to exaggerate.

The five-minute film took one week to make and was a huge release of energy for me. Elephants are fine, but you need some self-expression in your life too!

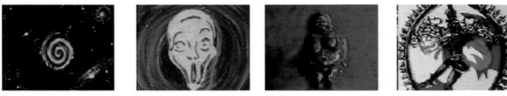

Cosmic spiral energy explodes in the work of Munch and pulsates in the organic forms of a prehistoric fertility goddess and the Hindu deity Shiva.

African cannibal and Mexican death masks are just as powerful visually as the Viking ship figurehead uncoiling into a Celtic Cross.

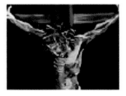

Gothic cathedrals stretch up to heaven, as did El Greco's figures, whilst Grunewald's crucifixion twists in pain.

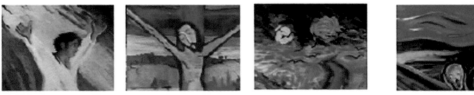

Feel the fear of Goya's victim about to be shot. Gauguin is symbolically decorative, whilst the images of Van Gogh and Munch both scream.

The German group Die Bruke were called 'expressionists'. Klee distorts for fun, while Bacon and some American expressionists distort for fear.

Egyptian art was for the dead, Greek for the living. Roman art copied the Greek but cut the fun, while Christian mosaics reflect an inner light.

An aloof Byzantine Madonna looks eastward to Indian Buddha and the immediacy of Zen. Back to the west and Giotto's uncelestial blue sky.

Piero della Francesca painted eggheads, and then flashy Baroque ended with the beheading of Louis XV1, after which Romanticism ruled.

Lose the dark background, Manet appears. Remove all black and look – Impressionism! Matisse explores colour, Picasso African masks.

Cubist mixed-media artists continued the African angle. Surrealists made dreamy heads. Next? You might show us.

THE FACE IN ART

An early film of mine was *Face to Face* in which I track a life from cradle to grave using the continuous 'smudge and click' method.

A face fits nicely in a movie screen, and is probably one of the most expressive parts of the human body.

I decided to make a film showing how artists had tackled the face in art down the centuries. Instead of using just pastel, I wanted to explore a wide range of media, so I tried to approximate as closely as possible the actual materials used by each artist depicted.

4 Sequential Action

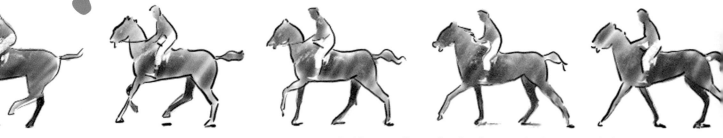

A 10 frame gallop cycle taken from Muybridge's original photographs.

1830–1904 Eadweard Muybridge

Eadweard (yes, it is spelt like that) Muybridge was a landscape photographer who in 1872 was involved with, as far as filmmakers are concerned, the most important wager in history.

It is said that Leland Stanford, Californian Governor and keen horse-race goer, made a $25,000 bet that at some point in its gallop a horse had all four hooves in the air, and he hired British-born Muybridge to capture this moment using the art of photography. The system used by Muybridge was a row of cameras triggered by tripwires stretched across a racetrack. He could then capture all stages of the gallop to a split second.

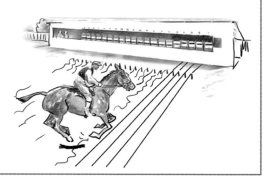

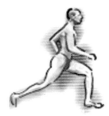 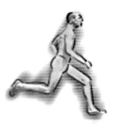 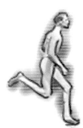 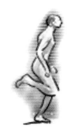

Funded by Stanford and the University of Pennsylvania, Muybridge went on to conduct an exhaustive study of animal

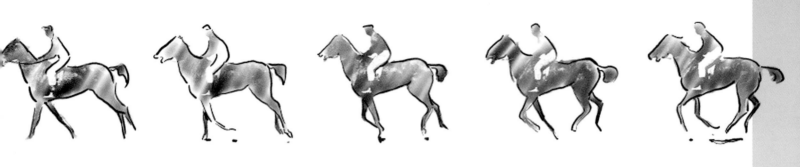

After many experiments Muybridge successfully photographed Stanford's horse Occident with all four hooves off of the ground (frame 10 in above sequence).

Especially useful for modern animators is the fact that the photographs of each subject were taken from three different camera angles.

His 'motion capture' process could be seen as the forerunner of the way we acquire movement information today in order to create CGI.

So all Muybridge's creativity was triggered by a simple (though costly) bet!

Ultimately he created some 20,000 images. It just shows how useful universities can be!

"Never underestimate the power of a sponsor who is on your wavelength!"

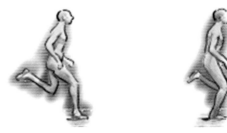

and human locomotion – for example, this cycle of a running man.

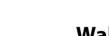
Walk Cycles

Muybridge is great as a starting point, but in reality there are far too many frames for one animator to handle in a lifetime. We need to know which are the key frames, the main ones that make the movement sequence work convincingly.

No 8 hooks into no. 1

Here I've drawn a simple energetic walk cycle in seven drawings. It works, see the DVD.

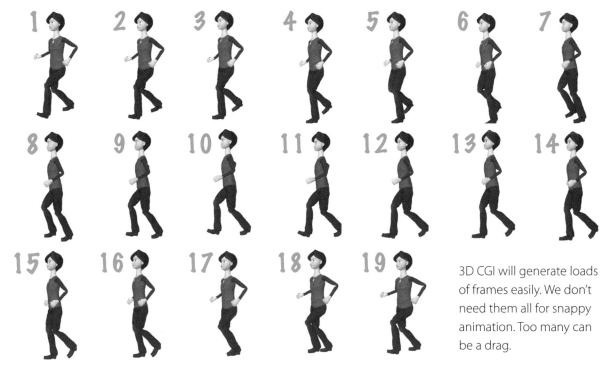

3D CGI will generate loads of frames easily. We don't need them all for snappy animation. Too many can be a drag.

Here are 19 frames from a much longer 3D walk cycle. Can you spot the eight main frames that are needed to make the character walk convincingly?

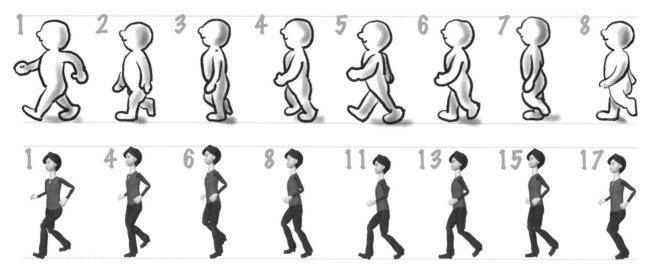

Key points in the 2D walk cycle are: No. 1, setting one step, body at its lowest; no. 3 crossover point, head at its highest; no. 5 is reverse of no. 1; no. 7 is reverse of no. 3. No.s 2, 4, 6 and 8 are in-betweens of the main poses.

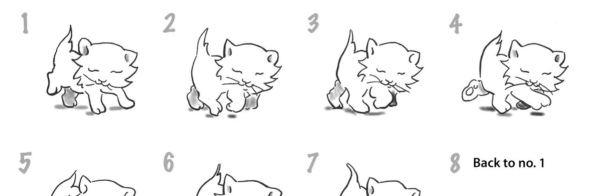

8 **Back to no. 1**

Four legs can move convincingly in far more drawings than are used in this sequence. However this cute cat only needs seven to keep on walking.

There are many excellent books on animation which will give full information on walk cycles of all kinds. My contribution here is to help you discover for yourself the main frames of a walk, limiting the number of frames to as few as possible.

Action Cycles

In 1985 I planned a series on the subject of 'How Your Body Works'. The pilot, *Bio & Bones* starred Bio, a one-celled amoeba-like character who guided us through major body systems. It was to be the first of a 13-part series for world TV. However, my agent said, 'No chance, TV does not want educational material, just entertainment'. She was right. Fortunately, times have changed. The plus for me was I learnt a lot about a variety of cycles. Here are some examples. Maybe they will help when you start animating your own TV series. I hope you have better luck than I did!

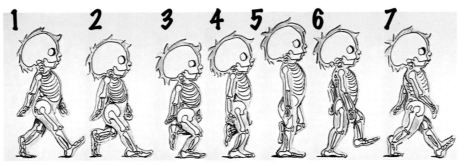

No. 7 is the reverse of no.1. The reverse of nos. 2 to 6 complete a full 12-frame cycle.

Walk cycle for a human. Note no. 3 is squashed and no. 5 is stretched to give extra bounce.

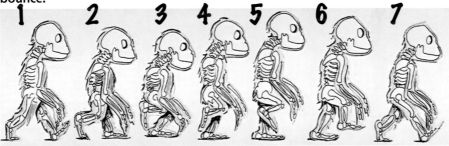

No. 7 is reverse of No. 1. The reverse of nos. 2 to 6 makes a full 12-frame cycle.

Walk cycle for a gorilla. The main difference here is the length of forearm and the stoop of shoulders.

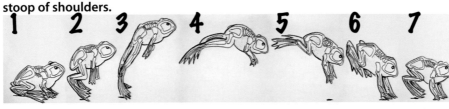

Nos. 1 to 7 complete one hop cycle.

Hop cycle for a frog. **Just off to the croak room.**

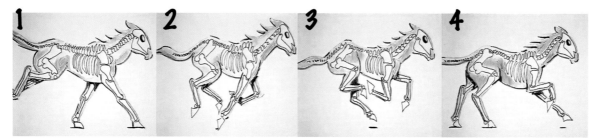

The gallop cycle for a horse. No. 4 hooks into the reverse of no. 1.

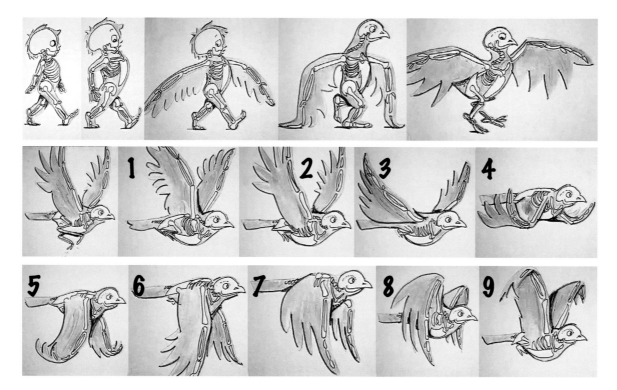

The sternum or breast bone becomes the anchoring keel in the skeleton of a bird. Arm bones grow and fingers take flight. A full flying cycle is shown from nos. 1 to 9.

Do look at all these cycles in action on the DVD.

Try experimenting with your own ideas.

As long as the action moves the way you want it to, then it's fine.

5 Smudge and Click

James Stuart Blackton (1875–1941)

In 1906, Teddy Roosevelt was in the White House, royalty ruled over most of the nations of the world, Coca-Cola replaced the cocaine in its formula with caffeine, Kellogg's introduced cornflakes, San Francisco was destroyed by a terrible earthquake and... the first animated film (well, most people say it was the first) was made by James Stuart Blackton.

He began his career as a music-hall 'lightning artist'. Quick on the draw but also quick on the uptake, he became a reporter for the *New York Evening World* and interviewed Thomas Edison. Edison is sometimes called the father of the modern world, having amassed 1093 patents covering key innovations in telecommunications, electric power and motion pictures. Blackton's imagination was grabbed by the idea of pictures in motion, and he went on to experiment in film and drawings, creating *Humorous Phases of Funny Faces* (see page 43).

'To invent all you need is a good imagination and a pile of junk'.
Thomas Alva Edison

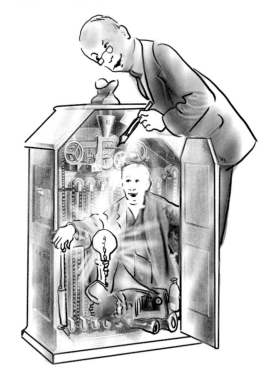

J. Stuart Blackton looks in on Edison inventing.

Having consulted the sequential images of Muybridge (see section 4) Blackton worked as follows:

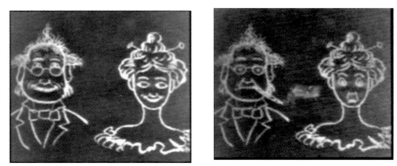

He appeared in front of the camera himself, presenting his work, then stop-framed the drawing of two faces in chalk on blackboard.

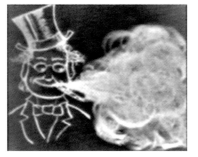

Substituting a cardboard cut-out for the drawn hat, the gent doffs his hat then blows smoke frame by frame into his girlfriend's face. Finally, Blackton's own hand appears in what is probably the first transitional 'wipe' to the final frames!

Blackton's film was released into theatres on 6th April, 1906 and was the first true American animated cartoon. The cigar smoker engulfing his girlfriend in clouds of smoke evoked gales of laughter.

Blackton went on to create more animated films that ran between his live-action shorts, before finally selling his company to Warner Brothers in 1925. His short animated films were to influence fellow American artist Winsor McCay, and artists in France, England and Russia who began making 'trick films'. A new medium of artistic expression had begun – one in which Cocteau, Dali and Picasso also expressed interest. Now it's your turn.

Smudge and click is not only the way the first animated film was made, it is also one of the simplest, most instant and effective ways to animate. There follow three very different techniques used by people exploring this method for the first time.

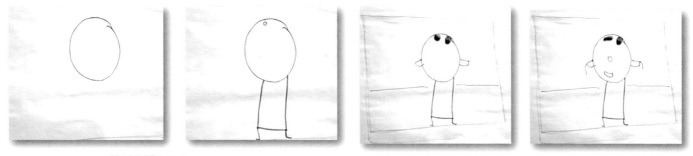

EXAMPLE 1

A special-needs unit created this sequence simply using a black marker pen on a flip chart. Two lumps of plastic gum formed the ever-changing eyeballs.

Having watched *Face to Face* the group were invited to draw their own character. The camcorder was firmly fixed to a tripod and hooked up to a TV monitor so all could see the action. One person drew a section, while another pressed the record button briefly. The audio dub facility allowed instant soundtrack to be recorded by the group upon viewing their work. This way the group had instant feedback on their animation. You could, of course, re-edit the whole movie in a computer at a later date.

One of the huge advantages of smudge and click is that a large group can create a film together. One person starts off the image (anywhere they like), while another films the marks made. Then they swap roles, and continue swapping, in pairs, throughout the movie. This way everyone contributes to the animated image and gets a go on the camera.

EXAMPLE 2

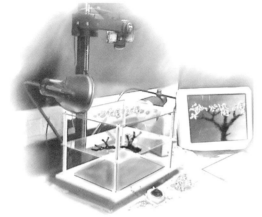

A group of four University of Sunderland students created this sequence using sand, peanuts, lentils and tea to show the four seasons. The multi-plane camera was constructed inhouse. Two levels of thick acetate were joined with wooden dowels and placed on a copy stand holding the digital still camera. All images were led through the camera lens to a computer which caught the frames and allowed instant replay. The movie could then be edited in a computer.

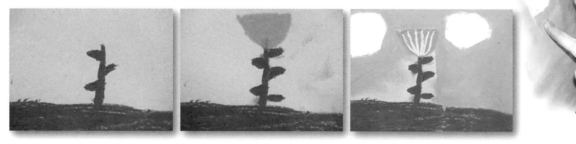

EXAMPLE 3

A junior-school pupil stuck her mobile phone into a lump of plastic gum and aimed at an A4 board propped up on the table. Using soft pastels she made a mark, took a still image, made another mark, took a picture, etc. for a total of 12 frames. She then ran the movie instantly in camera.

Go on, use your still or movie camera, mobile phone or computer, or invent a new method.
Have a go yourself!

Having trained in fine art, knowing nothing about animation (or Blackton), the first thing I did with my Super 8 film camera back in 1970 was to stick it on a tripod in front of an empty canvas, paint a stroke, click the camera, paint another bit, click the camera, all the time trying to remember to keep my hand out of the way between clicks!

When the film returned three weeks later it was out of focus and the paint reflected the light, making the image almost invisible. But it moved, magic!

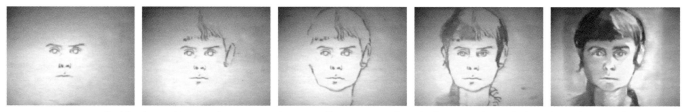

So I had another go, this time with non-reflective pastel and a bit more knowledge about how to focus a lens. I just drew a self-portrait to see what would happen. The bit where the drawing drew itself was interesting, then boring when it became still.

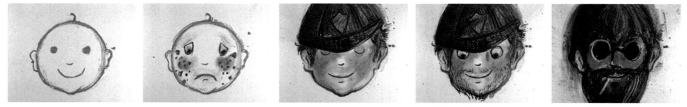

But it was still magic! So I had another go, this time taping a piece of stiff card to my drawing board on the floor with camera on tripod above. I drew a baby face, which sort of evolved itself into a complete life from cradle to grave in the space of three minutes.

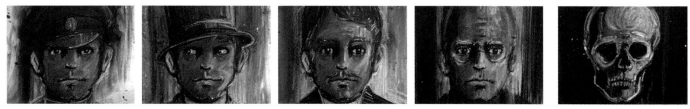

The film took two hours to make. It's probably one of the most successful films I've ever made. It's been screened in over 25 countries, and I often use it at the start of an animation workshop to encourage others to have a go in their own way.

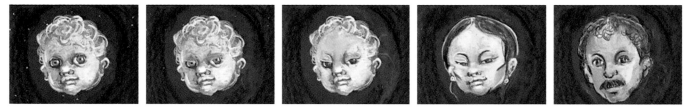

I've used this technique on many subjects since. To continue the faces theme, here are some from the title sequence of *New Year Round the World*.

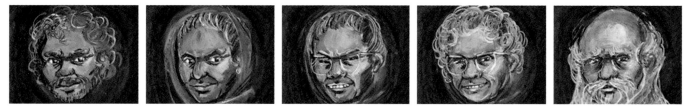

The New Year Baby ages via the faces of many countries, growing into the 'Old Year' before changing back again to the baby of the New Year celebrated all over the world.

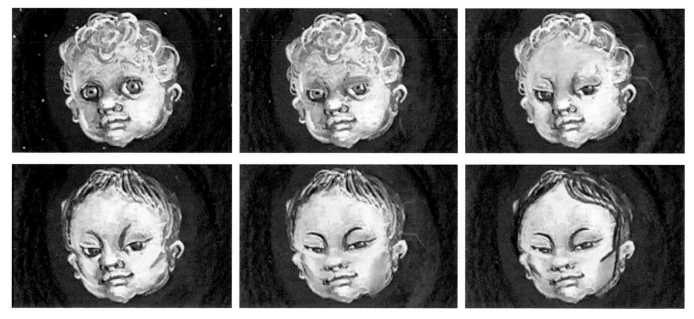

This six-frame sequence taken from *New Year Round the World* shows in more detail how the image is smudged. In fact, there were 12 different stages between key faces, each filmed for 3 frames, the final image being held for 1 second or 25 frames.

6 Creating Characters

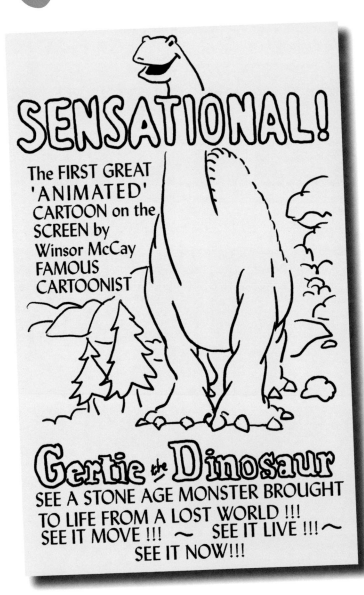

1911 Gertie the Dinosaur

Born in 1867 in Canada, Winsor McCay was mad about drawing. He was to invent a string of entirely original characters for comic books and films. In black tie and tails, whip in hand, he stood in front of his back-projected *Gertie* to present the only dinosaur in captivity.

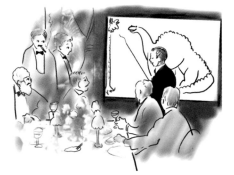

He then became part of the film himself, putting Gertie through her paces. A colleague traced 10,000 backgrounds onto rice paper. McCay did all the drawings of Gertie, which were then mounted on cardboard for registration under the camera.

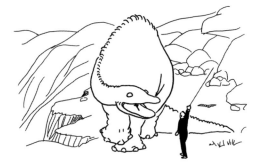

Gertie is the first star of animated films. She has personality and shows emotion. Like all convincing characters she grew from Winsor's own experience of observing life and drawing it first-hand.

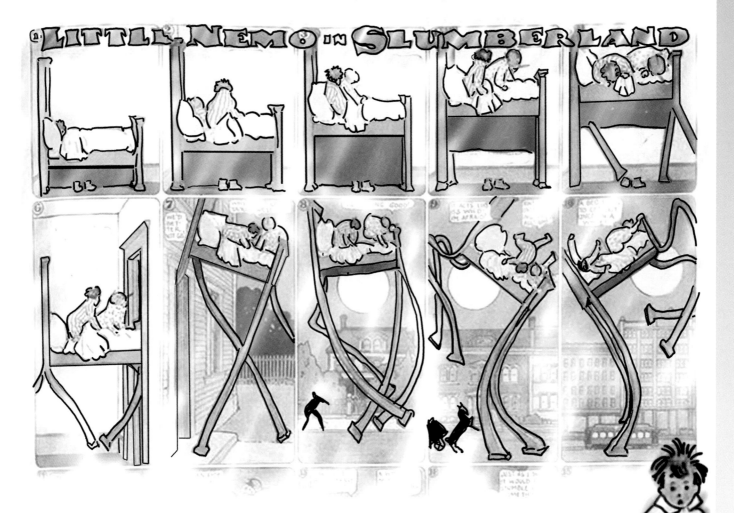

The comic-strip character Little Nemo was born in 1907. McCay's mastery of drawing, perspective, architectural design, page design and colour are amazing, and his surreal cast of thousands (including a walking bed) unparalleled.

This self-financed independent animator created characters and storylines that would take a group of people the size of Walt Disney Studios to emulate. It just shows that you *can* go it alone and succeed!

I taught art in secondary schools for 20 years. Often new pupils would say, 'I can't do art'. When asked why they thought this they'd usually say 'I can't draw as well as so and so'. The next few years were spent encouraging them to find *their* style reminding them that *everyone* is an artist in their own way.

Look closely at these pictures. Three very different characters painted the flowers shown.

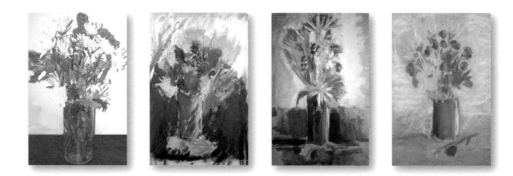

One was trained at art school to look but not to feel emotion. Another is an extrovert outgoing person, another more introverted and quiet. Who painted what? Answers are on the DVD. Which do you prefer and why? All are good in their own way, showing that art is a mix of observation and one's own character.

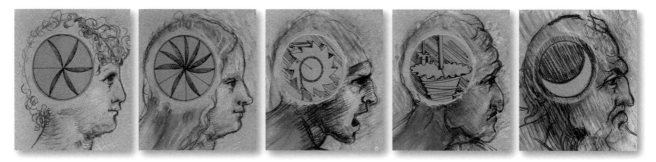

Above is a sequence of profiles from the title sequence of a film I made in 1984 on the work of Leonardo da Vinci. Having watched a TV programme on him in which the only work mentioned was the *Mona Lisa*, I was hugely motivated to make a movie showing all the amazing drawings he made from life other than the famous smile. To gather first-hand information on characters, he would evidently walk the streets of Florence all day, following a person who interested him, making sketches as he went. No doubt he would be arrested today, but thanks to his continual observation of the world, Leonardo has left us a wealth of stunning images and a legacy of discovery from the first parachute to the idea that the earth revolves round the sun.

Look back to David Sproxton's account of Nick Park's evolution as an animator (page 16). He reminds us that Nick invented *Wallace and Gromit* at film school. The characters grew from Nick's own experience of life. Three more examples of original characters that came from one person's first-hand observation of life:

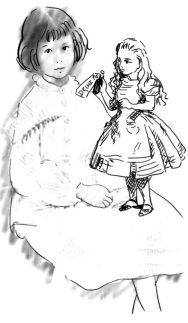

ALICE

In 1862 on a picnic outing in a rowing boat, 10-year old Alice Liddell asked maths professor Charles Dodgson to entertain her and her sisters with a story. The resulting story became *Alice in Wonderland*, which Dodgson published in 1865 under the pseudonym Lewis Carroll.

WINNIE THE POOH

A.A.Milne said that the animals Pooh, Piglet, Eeyore, Kanga and Tigger were not created by him. His son Christopher Robin played with them and gave them life and he just put them in a book.

PETER RABBIT

In 1893 the young Beatrix Potter wrote this letter (shown right) to Noel, a little boy who was ill in bed.

"It is much more satisfactory to address a real live child; I often think that was the secret of success of Peter Rabbit. It was written to a child – not made to order."

Beatrix Potter 1866–1943

My dear Noel,
I don't know what to write to you, so I shall tell you a story about four little rabbits whose names were –

Flopsy, Mopsy, Cottontail

and Peter

Characters seem to emerge in most cases from the animator's own observation and first-hand understanding of life. The more you see and feel, the more stuff you cram into your sketchbooks, the deeper and more memorable your characters will be!

I suggest you start dating your work as from now.

As you work on, it is very useful to look back over what you've done and see how you are evolving.

Looking back, I wish I'd dated more of my own stuff. However, with a bit of thought about where I was or what I was doing at the time of drawing, I've been able to sequence things in a hopefully accurate and helpful way.

Below are two of my drawings: one done at school aged 14, the other at art school aged 18. Can you see any differences?

I get round to creating a 'cartoon-style' character in 1963, aged 23.

The secondary school in which I taught art had a big old-fashioned hall. To brighten it up I was asked to make Xmas decorations. The Beatles were huge at that time, so I created *The 12 days of Xmas* using life-size caricatures of the group.

I get around to animating a character in 1970, aged 30.

Years later, after I was divorced and had spare time, I played about with a 'little boy' character. This sequence is from an early experiment. Only now do I realise that technically I'd gone about my first 'paper cel' animation in the same way as Windsor McCay 59 years before me.

Having created the boy, roughly based on my young nephew who was around at the time, I looked around for a character to act as a foil to him, one with whom he could interact and maybe tell a story. The answer was right in front of me!

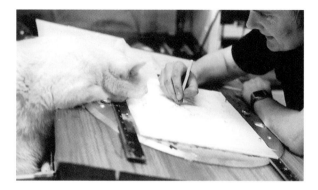

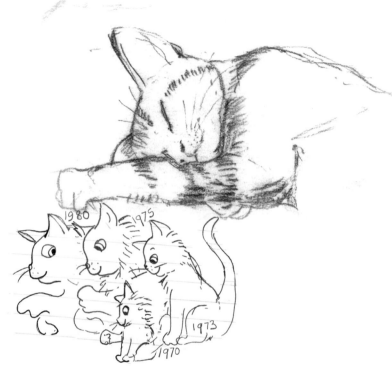

Whitey is the cat in the photo hanging over my warm light box. She has been followed by seven others between 1970 and the present day. Always a challenge in their mix of wildness disguised by a thin veneer of civilised elegance, cats are an endless source of inspiration for me. My cat shared the billing in *The Boy & the Cat*, joined with other feline friends in *Best Friends*, then took centre stage in one of Rudyard Kipling's *Just So Stories*.

Boy and the Cat

Best Friends

The Cat that Walked by Himself

7 Cel Animation

1914 Earl Hurd and the Transparent Cel

Independently of other animators, Earl Hurd patented the use of transparent celluloids fixed to register pegs as a way of saving on repeat drawings of backgrounds. The celluloids were much thicker than those in use today, and consequently there was a limit of two levels in the shooting process.

The *Bobby Bumps* films were inventive and amusing. The advantages of the cel process gave them much greater fluidity than previous cartoons. However, they still suffered from 'flicker', due to the lack of a properly regulated single-frame camera shutter and a failure to substitute a blank cel when reverting to only one level.

Earl Hurd later appeared as a screenwriter and consultant for the Disney Studio on *Snow White* and *The Seven Dwarfs*. Disney had used his transparent-cel idea from the time he had set up his animation studio, and was clearly aware of Hurd's expertise.

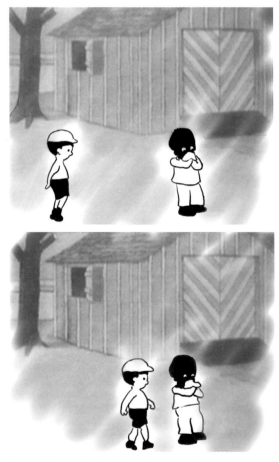

Two cels from Hurd's Bobby Bump *series created between 1915 and 1921.*

On the facing page you can see how the transparent cel was dropped into a frame and pressed flat against the background layer by a hinged glass front.

Hurd thinks,

'My new process beats drawing 10,000 backgrounds on rice paper!'

Disney thinks,

'I've "Hurd" of your great idea. Reckon with a bit of head scratchin' I could turn that gadget into a mutiplane camera in just 17 years or so.'

Cel levels: Digital

In 2000 Jay Film & Video commissioned us to make an in-house commercial for an electrical gadget that busted grime – what else but a 'Grime Buster'. Below is a breakdown of one frame of one second from the digital timeline, recording at 25 frames per second. Look at the opposite page to see how the idea grew from the exposure sheet.

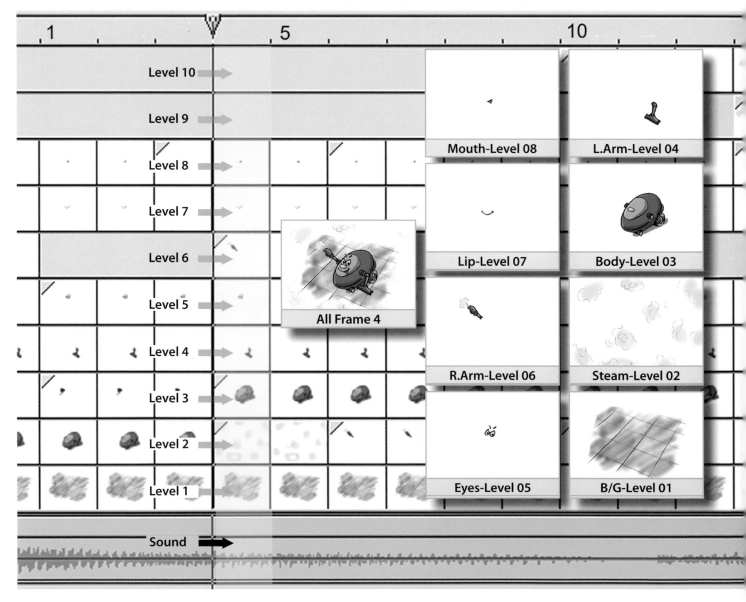

All Frame 4

Mouth-Level 08

L.Arm-Level 04

Lip-Level 07

Body-Level 03

R.Arm-Level 06

Steam-Level 02

Eyes-Level 05

B/G-Level 01

Below are the various stages via which we arrived at the cel levels for frame 4 – in this case, various hand-drawn analogue pencil drawings transferred to digital format. There was no need to laboriously time every frame of the sound track(s) by hand, as there was in the past; the computer now does it automatically.

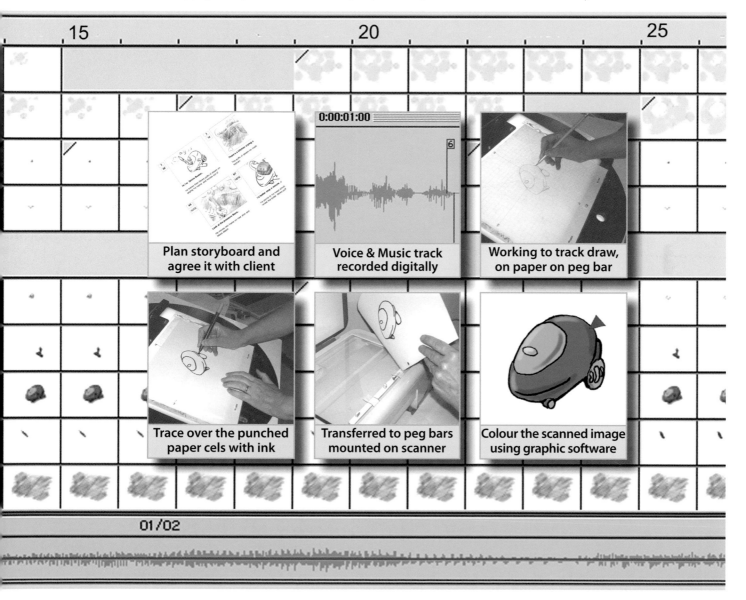

Plan storyboard and agree it with client	Voice & Music track recorded digitally	Working to track draw, on paper on peg bar
Trace over the punched paper cels with ink	Transferred to peg bars mounted on scanner	Colour the scanned image using graphic software

Cel levels: Analogue

In 1981 I was commissioned to produce a series of ten 10-minute films for a global TV audience based on Rudyard Kipling's *Just So Stories*. It sounded great – drawing one of my favourite subjects, animals, with great freedom to adapt the script and the animation to my own style. The only snag was that all ten had to be completed in a single year. The only way to do it was to resign from teaching. This was a typical month's work:

Plan storyboard and agree it with the client

Record the music guide track

Record the voice guide track

Time both tracks on 16mm magnetic film and make the bar sheet

Work to the guide track, and plan exposure sheet from the bar sheet

The drawings are done in pencil on punched paper

Trace over each drawing on cel in black pen

Paint the back of each sheet with acrylic paint

Film with the rostrum camera. Post the reel to the laboratory and pray!

Like Earl Hurd I used cels, but mine were thinner, so I could go up to four levels without losing colour. Here is a breakdown of just one frame (frame 4) of one second from *The Beginning of the Armadilloes*, one of the ten *Just So* stories I animated.

BG25

M1

Jaguar - J1

Eyes - E6

Tail -T2

Exposure Sheet- Page 62 Scene 10									
Action	**BG**	**4**	**3**	**2**	**1**	**Frame**		**Zoom**	**Pan**
script	25	M1	J1	E6	T1	366	1	8	0-0
H							2		
					T2		3		
							4		
							5		
e							6		
					T4		7		
							8		
r					T5		9		
						367	0		
T					T6		1		
							2		
					T7		3		
a							4		
					T8		5		
							6		
i					T9		7		
							8		
					T10		9		
						368	0		
				E7	T11		1		
							2		
					T12		3		
							4		
l							5		

Six cels from a sequence of 12 that made up 1 second of Mother Jaguar swishing her tail. Most frames shot on 'doubles' to make up 25 frames per second.

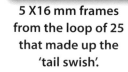

5 X16 mm frames from the loop of 25 that made up the 'tail swish'.

8 Rotoscoping

1916 Max Fleischer and Rotoscoping

Rotoscoping is a technique in which the animator traces over live-action film movement. It was invented by Max Fleischer around 1916.

Here we see him tracing a frame from a man signalling for a wartime propaganda movie. He is drawing with black ink on cel over a sheet of frosted glass. The movie projector behind is throwing a single frame of film at a time onto the glass, whilst a blower at the back keeps the whole operation cool!

Max's brother Dave was the live-action model for *Koko the Clown,* who featured with Max's own daughter in the early series *Out of the Inkwell* - a mix of live action and animation.

Fleischer Studios used groundbreaking and effective rotoscoping in their *Superman* series and in the feature-length *Gulliver's Travels* of 1939.

However, they are mainly known for creating Popeye and Betty Boop.

The Fleischer Brothers also developed combining cel animation with a rotating 3D background. This produced an effect similar to that of Disney's multiplane camera.

Always inventive, in 1924 Max Fleischer became the first to produce sound cartoons. Indeed, many of the digitised special effects we see today have their roots in this little-known pioneer's work.

Max died in a film veterans' home in 1972, penniless, a few days after signing a lucrative new contract for Betty Boop cartoons.

As an impressionable 44-year old, (I'm a bit of a late developer), in 1984 I remember being glued to the TV set as it screened a music video by A-Ha called *Take on Me*. At this point I had never heard of rotoscoping. I just felt hugely intrigued by the magical mix of 'real' and 'unreal' moving images.

My first thought was 'How was that done?' My second was 'I'd love to have a go at something like that.'

The A-Ha video was produced on film by The Framestore using methods similar to Fleischer and Disney. The process has since been emulated digitally by countless others ever since. Whatever technical method you use, knowing the following key elements will help your work to be less arduous and more effective whatever hardware or software you may use.

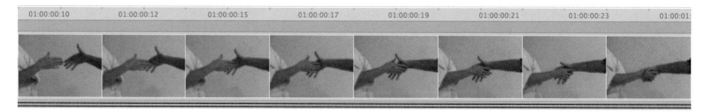

Try to choose live action sequences with plenty of movement. Static shots tend to boil as you trace over the same image again and again. Your movie will probably have 25 frames per second. That's a lot of drawing. Also, the closer together the movement the more that boiling is increased.
Of course *if you like the boiling effect, then fine*.

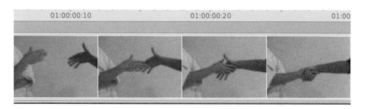

If not, then in your software package take the time of your movie down by 50%. This halves the work and doubles the visual power. Once you have rotoscoped the whole sequence, just bring it back into your editor and double the length.

Firstly, choose your live action subject with care. Shooting against a plain background helps, but is not essential, as any items not required in the final movie can just be ignored! Always place your camera on a tripod – you have enough of a job dealing with the live-action movement without having to tackle camera shake too.

Look at the sequence of drawings 'A' and 'B' and decide which is clearest in defining the actual shapes of the hands and their movements.

Both were hand drawn with a graphics tablet using a standard animation package.

'B' has an outline drawn with some understanding of the shape of the hands. The outline of 'A' is jellylike as it traces quickly round the basic shape without any thought of how it works. Note the way the base of the 'B' thumb shows the shape of the palm. The inner shading of 'A' is flat, whilst 'B' has small areas of shading placed beneath fingers to clarify their position in space. Don't just trace – think!

In 1997 we created a TV pilot to update the stories of Hans Christian Andersen for the 'Youth of Today'. The pilot was not successful but we feel that the rotoscoping was! Here is a selection from three stories showing some of the methods used.

The Ice Queen is a top executive ruling her empire with a rod of cold steel. I tried to show this by using clean-cut drawn rotoscoping over glassy backgrounds.

In *The Ugly Duckling* I used Van Gogh Cloner tools to lend a lyrical, romantic feel to the swan, contrasting with the wacky punk rotoscoping of the little duckling.

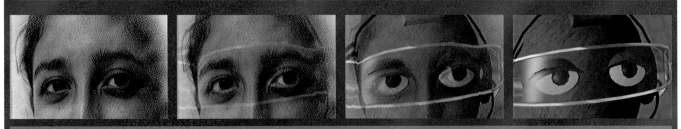

Starting from chalky rotoscoping, we see a young girl transformed via morphing into a 3D CGI rendering of a 21st century Little Mermaid.

As I sat animating in my front room,
so my Mother sat crotcheting.

She sold her stuff to a baby shop and I sold mine to television.
She put together thousands of stiches and I put together thousands of drawings.

Over time an image grew in my mind of my Mam crocheting the universe, and as I listened to a jazzed-up version of Beethoven's *Ode to Joy,* the whole flow of life in nature and my own life began to weld together into a whole. Out of this came the concept for *Lifeline.* I began planning it in 1985 or so, but though the images were clear in my mind, how to put them on film escaped me. Time escaped me too. I was now running my own limited company and working round the clock producing animation for clients. Finally, in 2004, I had the time and technology to produce the movie. It was completely rotoscoped from start to finish so as to visually catch the line of life.

9 Principles of Animation

1919 Otto Messmer creator of Felix the cat

In the John Canemaker film, *Otto Messmer and Felix the Cat*, Otto Messmer walks up and down - hands behind his back - just as Felix does when he's thinking. Messmer is Felix. Like many animators he simply animates himself on screen, without ever knowing it!

Pat Sullivan produced Felix films but Otto Mesmer created and animated him. The catchphrase and song for Felix *'Felix Keeps on Walking'* were a smash hit in their day.

Mesmer devised a walk cycle for Felix that became a standard in American animation.

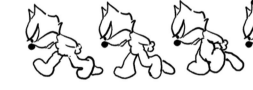

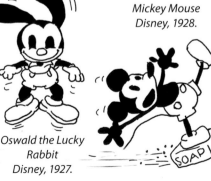

Felix the Cat
Paramount, 1919.

Oswald the Lucky Rabbit
Disney, 1927.

Mickey Mouse
Disney, 1928.

Feline Follies was released by Paramount in 1919. Popular songs and merchandising raised Felix's fame to cult level, setting the pattern for the Disney Studios and for most animation studios to the present day.

Many animated films of that era now seem rather slow and predictable. However, the *Felix* series has, for me, stood the test of time because of its great use of graphic wit. The animators allowed their medium to be crazy – although the films obey real-life laws of motion, the events that occur can be totally surreal.

The storyline is based on a poker game. Felix finds it plain sailing until fate deals him a dud hand. He uses his head and graphic line to save himself. Jack has plenty of chips but not enough spades. Felix comes up trumps!

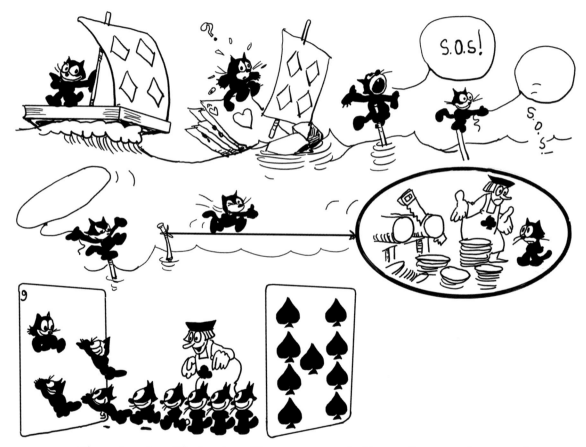

Above is a simplified series of images re-created by me from comic pages drawn by Otto Messmer. It uses two very useful tricks that we can all learn from when animating.

1 *Play with your subject and let it discover new worlds.*

2 *Allow the graphic shapes themselves to help create the storyline.*

From Felix onwards animators began devising 'key principles' to help create the feeling of motion and weight. All studios work from slightly different combinations, so I've begun from the theories behind most of them:

Newton's Three laws of Motion

Newton's First Law of Motion

'Every object remains at rest or uniform motion unless acted upon by an external force.'

OK, so how does this 'law of inertia' help us animate?

Objects keep on doing what they're doing!

Note that not all parts of an object stop at the same time, causing **follow through and overlapping.**

Open your mind and say 'Ah!'

Until another force stops them.

Squash and Stretch *add greater energy and weight to an action – for example, the apple landing on Sir Isaac Newton's head!*

Newton's Second Law of Motion

'Every object has mass and weight and moves only when force is applied to it, and won't stop unless a force acts upon it. The greater the mass, the greater the force needed.'

Frame

We feel this law instinctively.

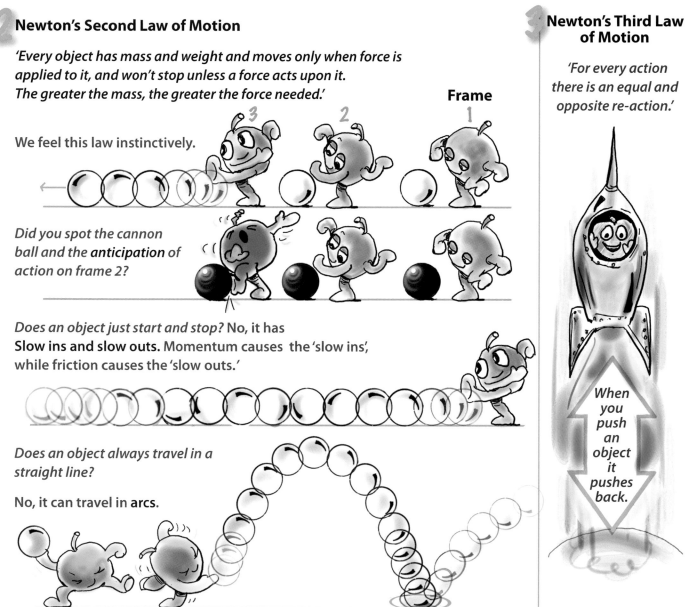

*Did you spot the cannon ball and the **anticipation** of action on frame 2?*

Does an object just start and stop? No, it has **Slow ins and slow outs.** Momentum causes the 'slow ins', while friction causes the 'slow outs.'

Does an object always travel in a straight line?

No, it can travel in **arcs.**

Newton's Third Law of Motion

'For every action there is an equal and opposite re-action.'

When you push an object it pushes back.

Truly creative animation grows from a knowledge and practice of the principles involved, plus – and it's a big plus – elements of the animator's own character. Act out the movement you're animating. Get inside it, feel it, and then you can project it to others.

My own 6 Key Principles

Wherever your idea for animating comes from – whether it's your own invention or a brief from college or client – it's what you do with it that counts. My own six of the best might help.

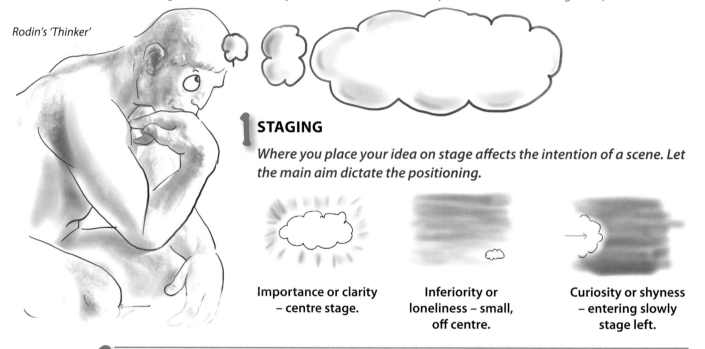

Rodin's 'Thinker'

1 STAGING

Where you place your idea on stage affects the intention of a scene. Let the main aim dictate the positioning.

Importance or clarity – centre stage.

Inferiority or loneliness – small, off centre.

Curiosity or shyness – entering slowly stage left.

2 PERSPECTIVE

A basic knowledge of perspective can help stage your idea in space, whether you use 2D drawn or 3D computer-generated animation.

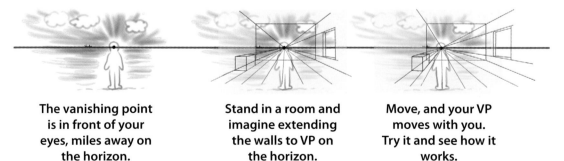

The vanishing point is in front of your eyes, miles away on the horizon.

Stand in a room and imagine extending the walls to VP on the horizon.

Move, and your VP moves with you. Try it and see how it works.

3 CHIAROSCURO *From the Italian word meaning 'lightened dark'. No need to guess where light will fall, just follow one simple rule.*

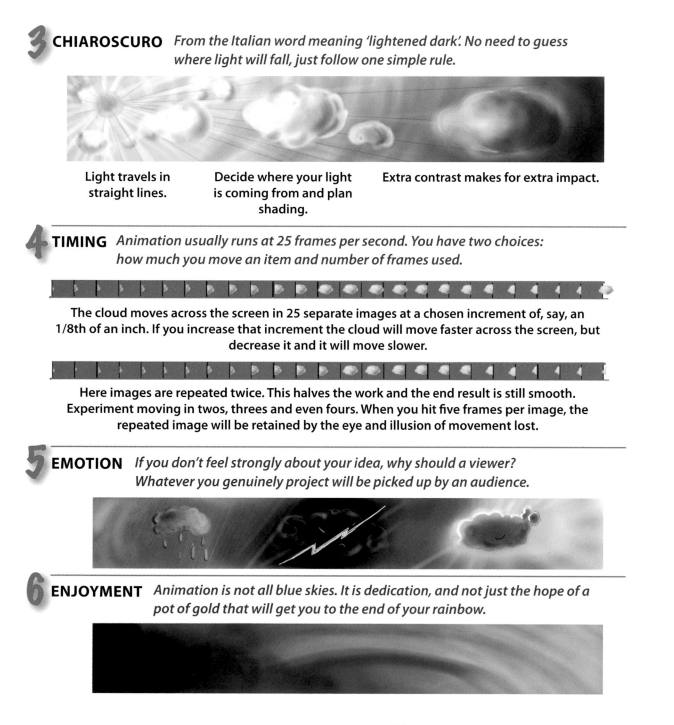

Light travels in straight lines.

Decide where your light is coming from and plan shading.

Extra contrast makes for extra impact.

4 TIMING *Animation usually runs at 25 frames per second. You have two choices: how much you move an item and number of frames used.*

The cloud moves across the screen in 25 separate images at a chosen increment of, say, an 1/8th of an inch. If you increase that increment the cloud will move faster across the screen, but decrease it and it will move slower.

Here images are repeated twice. This halves the work and the end result is still smooth. Experiment moving in twos, threes and even fours. When you hit five frames per image, the repeated image will be retained by the eye and illusion of movement lost.

5 EMOTION *If you don't feel strongly about your idea, why should a viewer? Whatever you genuinely project will be picked up by an audience.*

6 ENJOYMENT *Animation is not all blue skies. It is dedication, and not just the hope of a pot of gold that will get you to the end of your rainbow.*

10 Cut-out Animation

1925 Lotte Reiniger and Cut Outs

Lotte Reiniger (1899–1981) made almost all her films in a unique cut-out technique. As a child she snipped figures from old papers. Later, after failing to make the grade as a dancer in Max Reinhardt's theatre group, she began cutting silhouette titles for a German film version of *The Pied Piper*, and animated wooden rats when the real ones ran off the set.

In order to achieve her characters' smooth movements she used as many as 25 elements joined together with fine lead wire.

'I believe in fairy tales not newspapers'.
Lotte Reiniger

Lotte Reiniger and film figure, 1938.

Lotte at work, 1975.

Light streamed through the windows, falling on a stout, grey-haired woman whose energy belied her years. Her wrinkled hands moved quickly, wielding a pair of delicate scissors on a large backlit sheet of celluloid. I had been itching to do more than cut tape, make hinges and run errands. So I asked if I could help. She peered over her spectacles and said dryly, 'I thought you'd never ask'. So began my five years of apprenticeship and collaboration with Lotte.

Film Making with Lotte Reiniger by Patricia Martin

Reiniger's masterpiece is the 65-minute *Adventures of Prince Achmed* (1923–1926), widely acknowledged as the world's first full-length cartoon, and completed before Mickey Mouse was even a squeak.

She worked on a homemade multiplane rostrum, aided by her devoted husband Carl Koch.

Her friends included Charles Chaplin, Fritz Lang and Jean Renoir, all originals in their own fields.

Look at the hands in **Prince Achmed** *and then at those of Lotte aged 39 and 76.*

Cut-outs as an expressive animation medium are not often used today – the reason being, I think, that it appears to be a medium with limited possibilities. However, its very simplicity can lead to some powerful effects, as we have seen in the work of Lotte Reiniger.

There follows four examples from the work of University of Sunderland students. Each, I feel, shows a different aspect of the peculiar strengths of cut-out animation.

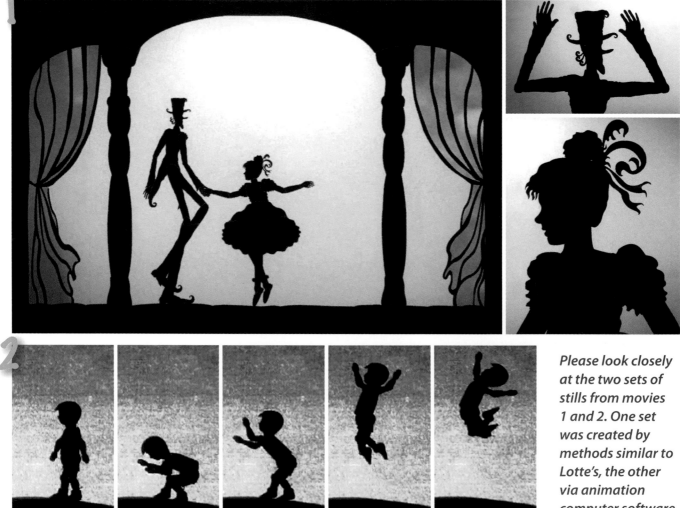

Please look closely at the two sets of stills from movies 1 and 2. One set was created by methods similar to Lotte's, the other via animation computer software. Which is which?

3

No prizes for spotting the big bad wolf and an unfortunate little pig. If you get the timing spot on, cut-outs can save a lot of work on lip-synching. Here four cut-out lip positions are shown out of the seven used for the wolf to chat. Then two key positions used for his huff and puff! The crazier the cut-outs the funnier the movie can be.

Cut-outs can be very expressive

4 Using photographs mixed with graphics can give very powerful surreal effects that treat serious subjects in a unique and compelling way.

Returning to the saga begun in section 6, I continued the school-hall Christmas decorations every year, and in 1974 chose yet again the 12 Days of Xmas as the theme. This time I used the layout of the decorations as a storyboard for my first cut-out animation. It involved Santa Claus as the link figure for an ever-growing menagerie of 'presents', and was set to a soundtrack provided by the school choir.

The animation throughout is simple and jerky. Run cycles often consist of just two sets of cut-outs. Plain backgrounds help the clarity of action.

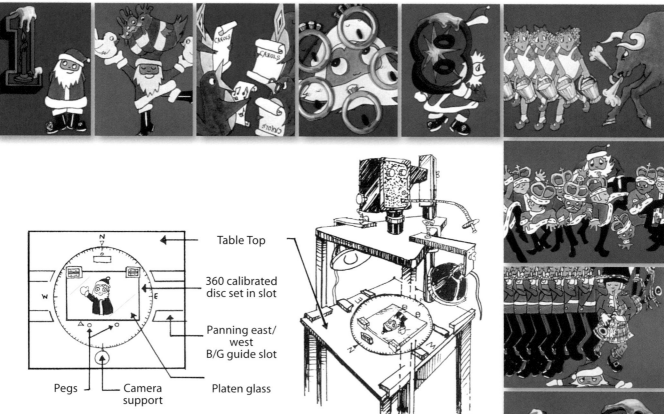

My rostrum was a tea trolley, with a broom shank to hold the clockwork film camera. You could use a digital movie or still camera, hooked straight to your computer if you wish. A hinged 25 x 20 cm (10 by 8 in.) glass or Perspex panel keeps the cut-outs flat. Peg bars fit holes in the background paper, made with a standard office punch, to keep all in register.

As I also taught the history of art, I next tackled the idea of using animation as a way of interesting students in art and artists. I began with Michelangelo showing his main works including the early *David* and the Sistine Chapel ceiling. Backed by Beethoven's 5th, the film advances rapidly in an attempt to capture the artist's own action-packed creative drive.

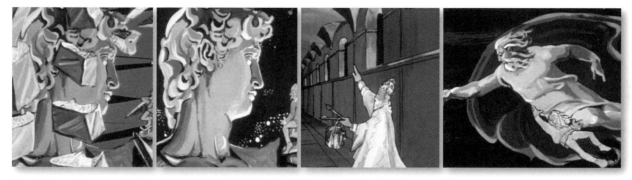

The following year, in 1976, I used not only cut paper but also cut cels to create *Four Views of Landscape*. The film portrays the differing approaches to the landscape in front of them of Constable, ('down to earth'), Turner, ('the dramatic moment'), Monet ('spotty Impressionist') and finally Van Gogh, ('emotional').

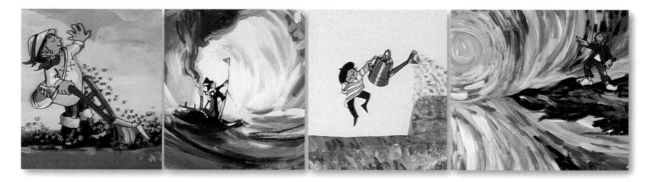

'This is a jokey and highly imaginative film; like all the best jokes it has its basis in an intelligent idea and does not insult its audience.'

Terry Measham, Education Dept, Tate Gallery, 1977

Although made on the most primitive equipment with simple cut-outs, these films went on to be shown on TV in countries around the world. Expensive gear is not always needed to make a successful movie – just a genuine interest in your subject and an appropriate choice of medium for the message you want to put over.

11 Visual Music

1931 Oskar Fischinger and visual music

Oskar at work on his homemade animation rostrum in Munich in 1926. You can see that his early training as an engineer was put to good use!

Oskar Fischinger (1900–1967) was an Austrian animator with very strong views on how images and sound might link together in what he called 'visual music'. The more I read about this enigmatic man the more confused I became, so here I have gone back to his own (edited) words to attempt to clarify the power and present-day application of his ideas.

'To write about my work in film is rather difficult. The only thing to do is to write why I made them. When I was 19 I had to talk about a work by Shakespeare in our literary club. In preparing for this I began to analyse his work in a graphic way. On one sheet of paper, starting with a horizontal line, I put down all the feelings and happenings, in graphic lines and curves. These showed the dramatic development of the work and the emotional moods very clearly.'

Building on this basic method, he added the 'cinematic element' of animated images and sound combined. His abstract multimedia movies were highly acclaimed and well ahead of their time.

A sequence of stills from his promo film shot in 1933 for the advertising agency Tolirag. The film's premise was based on their apparent slogan, 'Tolirag reaches all circles!'

Oskar veered between making films just for himself and working for the commercial world. His most well-known advert was 'Muratti Marches On', in which cigarettes march about with military 'goose-stepping' precision. His innovative idea has been copied many times.

Marching cigarettes in 'Muratti Marches On',
made by Fischinger in 1933.

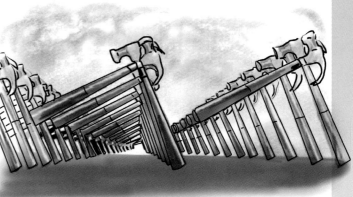

Marching hammers in a 1979 animation
by Gerald Scarfe for Pink Floyd's 'Another Brick in the Wall'.

Elfriede Fischinger, his wife, was the only one permitted in the room when the animated cigarette film was shot. In an interview in the 70s she describes her input into the film. *'My main task was to dye the sawdust groundcover and keep it smooth with a long-handled toothbrush – to be able to get between cigarettes. We had to overcome a lot of tricky difficulties, so it would not be easily detectable how it was done. The illusion of the cigarettes moving by themselves proved to be a startling and successful surprise. The audience clapped approval and delight at the premiere before the film was half through. This little advertising film had a run of one full year in one of the most important theatres in Berlin.'*

Finally back to Oskar's own thoughts. *'Now a few words about the usual motion-picture film which is shown to the masses everywhere all over the world. It is photographed realism – photographed surface realism-in-motion. There is nothing of an absolute artistic creative sense in it. It copies only nature with realistic conceptions, destroying the deep and absolute creative force with substitutes and surface realisms. Even the cartoon film is today on a very low artistic level. It is a mass product of factory proportions, and this cuts down the creative purity of a work of art. The creative artist of the highest level always works at his best alone, moving far ahead of his time.'*

'If you are alone you belong entirely to yourself. If you are accompanied by even another companion you belong only half to yourself, or even less.' Leonardo da Vinci

Visualising a soundtrack

So let's put Oskar's idea into action. There follow two versions of a well-known Shakespearean phrase. It almost could be 'to be or not to be' ... but it isn't!

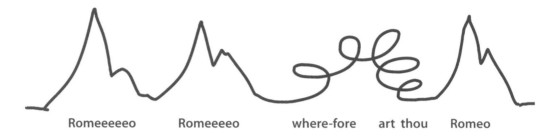

Romeeeeeo Romeeeeo where-fore art thou Romeo

Say it out loud and follow the 'sound pattern'.
Now try this next version:

Rooooomeeeeooooooooooooooooo where on earth ARE you

Why not try out your own version of this phrase, or think of another and draw it out along one horizontal line. See if others can follow it without knowing the words.

Here is a well-known nursery rhyme for you to translate. You'll find the answer on the DVD.

(Clue: it squeaks and ticks).

'The kind of mental image needed for thought is unlikely to be a complete, colourful and faithful replica of some visible scene.' Rudolph Arnheim, Visual Thinking, 1969.

Fischinger was not alone in his 'visual music' concept; many others were thinking along similar lines, and colours, at the time, and have done so ever since. Now you can join them very easily, if you have not done so already. You'll find that creating abstract imagery is not as tricky or as unconnected with reality as you might have thought.

On a scrap piece of paper draw any marks that come to mind when you think of 'ANGER'.
Do not use any recognisable imagery, such as tears or hearts, etc.
 – just lines: straight, curly, dark, light, short, long, whatever comes into your mind.
Below are four examples of emotions that I've drawn. Can you guess them without looking at the upside-down titles?

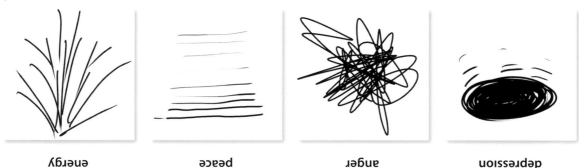

энергy peace anger depression

Once again, try this out on your friends using these and other emotions. No one is right or wrong. Each is a personal expression.

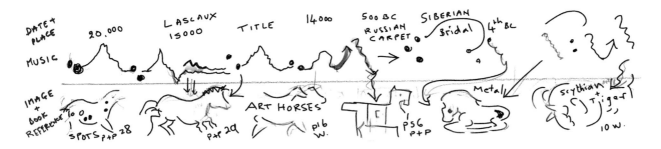

I have always used this 'visual soundtrack' method since I began animating in 1970.
I never realised until I started researching for this book that others used it too! Try it, it works.
Above is the start of my visual plan for the movie Art Horses (see Section 1 on DVD).

Visualising music

When I taught the history of art I always used Mondrian as the classic example of how an artist can work their way from realism to abstraction. In 1979, when the Tate Gallery encouraged me to make a film about him I thought at first it would be very static and set to *musique concrète* or a similar kind of 'abstract' music. It just didn't work. So I asked a museum in Amsterdam if they had any of Mondrian's own words about his work. They did. Suddenly everything about Mondrian made sense.

Six frames from the 16 that made up my guiding storyboard.

He was mad about boogie and had it playing whilst he painted. On Friday nights he went out and boogied! Then came his magic words saying, in rough translation, 'In my painting the horizontal and vertical are the 8 beats to the bar and the colours are the tune.' I went ahead and timed Hank's Boogie, basing the whole film on his words and putting him in it, dancing. Below you see stills from the movie, which faithfully followed the 16-frame storyboard, which in turn followed the music.

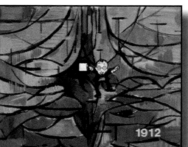

This movie runs today in Mondrian's own house in Amersfoort, The Netherlands, being used as an educational introduction to his work.

12 Heroes

1940 Walt Disney's Fantasia

For innovation and artistry this film must be Disney's masterpiece. Taking seven works by classical composers his team of over a thousand animators created a cast of thousands, including dancing thistles, fishes, balletic hippos, and one of the most powerful images of the Devil you will ever see. Oh, and there's also the creation of the universe. Buy a DVD. Watch, listen, learn and enjoy!

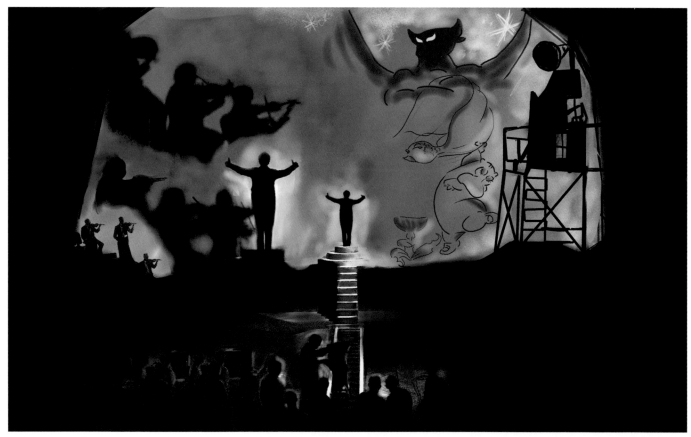

Based on a photograph of a live-action shoot of the orchestra in concert. On-screen is my own collage of a few of the film's extraordinary characters.

The Disney Studios invited Fischinger to work with them on 'The Concert Piece' (Disney's working title for the piece). Though he was not at his best working in a group, Oskar accepted. He later quit when Disney started to simplify his concepts for animating abstract images. Because of that simplification, carried out with understanding, Walt was able to present the world's first animation of abstract art set to music in a commercial feature film. In his ingenious animation of 'The Soundtrack' (an intermission in the middle of the film) he makes us laugh as well as think, and through that laughter we open our minds to new concepts.

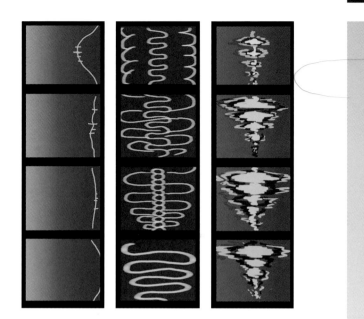

A shy soundtrack enters, plays a harp glissando and then a trumpet blast!

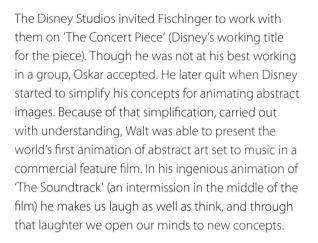

'I don't like it.'
Disney the perfectionist caricatured by one of his team.

The film was a labour of love for Disney, who wanted to bring classical music to all. Many music critics thought it 'too populist', and the general public wondered where the gags had gone. Crushed when the film proved a flop at the box office, Walt still knew in his heart that he was on the right track. He said, '*Fantasia* is timeless. It may run 10, 20 or 30 years, it may even run after I am gone.' Indeed, as Walt suspected, its appeal has endured, proving that you should always stick to your gut instincts, however long you may have to wait to see whether you were right or not!

Heroes

Disney was hugely influenced by looking at nature and listening to music. He also added a little mouse that he spotted in his studio, which turned out to be not only his alter ego but the Disney Studio hero of all time. Your heroes and influences will be totally personal to you, growing out of your own life experience. I can only ask that you focus on what they are and how they might be of value in your work. However, I can offer a few guidelines as to how archeytypal 'heroes' might be created. They are not definitive, just some concepts which you can tailor to your own style.

Here is a basic human figure with 'standard proportions'. The head fits approximately seven times into the body. This figure is so 'normal' that it does not strongly move us emotionally.

Exaggerate the muscle structure and a stronger character starts to emerge. He does not look as weak as No.1, but he still does not evoke any strong emotions in the viewer.

Make the muscles even bigger. Add hair and power underpants.

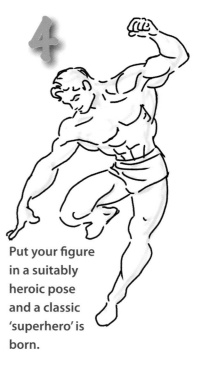

Put your figure in a suitably heroic pose and a classic 'superhero' is born.

5 Starting from No.2, enlarge the muscles and pose the figure into a kung fu-style fighting stance.

6 Add wild hair and modern costume with an oriental feel.

7 Large eyes with an eastern touch produce a 21st-century Manga hero.

8 If we make the head fit only two times into the body, a child-like character appears.

9 You can make it a goody-two-shoes cutey hero...

10 ...or a little devil!

Heroes

Perhaps I feel an affinity with *Fantasia* as we were both born in the same year. I remember first seeing it in a cinema with my Mam when I was six, laughing at the 'Soundtrack' sequence then holding my breath as the devil emerged out of a mountaintop in Mussorgsky's *Night on Bald Mountain*. Since then it has had more influence on my development as an animator than any other movie. In fact it was the reason I began to animate at all. I just loved the concept of listening to a soundtrack and seeing what images emerged in my head.

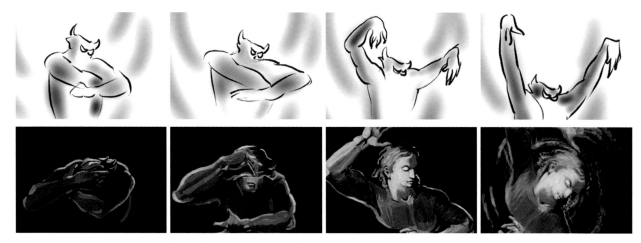

In 1976 I used the powerful unfolding gesture of the *Fantasia* Devil at the start of my film on Michelangelo. The Christ figure from his 'Last Judgement' spins into a spiral galaxy. The galaxy image was one I first saw in the **Rite of Spring** sequence from Fantasia.

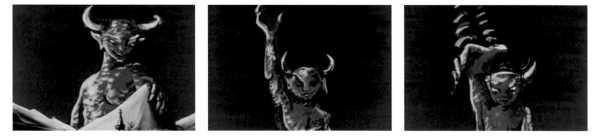

Vladimir Tytla, one of Disney's top artists and my hero of all time, was chosen to animate the Devil, specifically Chernobog, the god of evil in Slavonic myth. In 1983 I tried to capture the enormity of a character as big as a mountain in *Dance Macabre*. I screened it at a friend's little boy's sixth birthday party. He and his pals screamed, I thought 'Oh dear, should not have shown this.' Then they shouted, 'Again, again'. That little boy was Tim Burke, Oscar winner for Best Visual Effects on *Gladiator* in 2000. You never know how far influences will go!

In 1983 I used an electronic version of *Night on Bald Mountain* for my film on Expressionism (see page 34). Disney's sequence based on part of Beethoven's *Pastoral Symphony* was etched on my mind. I had grown to love that piece and in 1976 I used it to animate *Four Views of Landscape* (see page 77). There is a short sequence midway through which just sounded like little dabs of paint being applied. Out of this grew an Impressionist Monet at work, and out of that grew the rest of the film. Looking back I realise that I had absorbed a love of classical music thanks to visiting cinema screenings of *Fantasia* not only at the age of six but many times later, as it was released at intervals in different parts of the world. It's so easy now just to buy a DVD of your favourite film – you don't have to wait six or seven years between screenings like I did.

Finally, a mention of the amazing 'evolution' sequence from the start of *Fantasia's Rite of Spring*. I always loved the way the fish's fins became legs as it emerged onto dry land. In 1980 I animated my own film *Evolution*, set to Beethoven's *Symphony No.1*.

So I've ended up making over 100 films, most of them owing something to *Fantasia*. The trick is to use your heroes as springboards to your own creativity. That way they provide inspiration to keep you going but you make an end product that is original in concept and produced in your own style.

So get springing NOW!

13 Working as a Group

1943 United Productions of America

Disney's Grumpy from Snow White and the Seven Dwarfs *cannot figure out what's happening in cartoonist Saul Steinberg's self-portrait. On the right, a cool character drawn by Grim Natwick at UPA sips his coffee in a TV ad of the day. 'What's up Doc?'*

As the demand for cartoons, both still and animated, grew throughout America so did the demands of the artists for better pay and conditions. Organised strikes throughout the industry culminated in mass walkouts at the Disney studios in 1941. The strike led to a loose affiliation of animators coming together under the banner UPA or United Productions of America. They reckoned there was space in animation for more than just the Disney style. Looking at what was going on in comics, illustration and design, they decided to build some of this new thinking into their animation. The fact that animators were working on tight budgets and short TV deadlines also contributed to a flatter, streamlined, comic-book style that is still with us today in commercials and in many children's TV series.

Mr Magoo was the first popular character to emerge from UPA. He was a crotchety, near-sighted, lovable old coot who was always stumbling into trouble, and attempting, though never quite managing, to keep up with the latest gadgets. Though director John Hubley was partly inspired by his bull-headed uncle Harry, the character was the result of the collaborative effort of the UPA staff who worked on those first films. He went on to appear in numerous theatrical shorts, commercials, full-length movies and TV specials, and in three TV series.

Gerald Mc Boing Boing was an ingenious mix of abstraction and realism. Looking back at section 11 we see Oskar Fischinger exploring visual music, and in section 12 we have Fantasia's 'Soundtrack'. Gerald is a witty embodiment of both, a little boy who 'speaks' sound effects instead of words. It is a brilliant way of putting across 'visual music' in a fun way. Here he 'boings' into a machine that translates his sound into a voice!

With UPA we move from classical music to jazz, and from the Renaissance concept of art to that of Picasso and Co. All Gerald needed to do was add a few text messages to his family, and he would be quite at home in the 21st century!

These images, from UPA's version of Edgar Allan Poe's The Tell-Tale Heart *(1953), show how far the creators of Mr Magoo travelled in a few years. It was the first animation to be awarded an X certificate in Britain. It just shows what can happen if you form a group, share skills and welcome change.*

Working as a group

Ian Sachs is a splendid 'classic' animator in his own right and is very experienced at working at many levels in studios both huge and small. The process he described to me, which I have simplified due to lack of space, shows how the basic flow of work can be managed in a smallish studio. In larger ones, jobs are split and more people added. In smaller ones fewer people do more jobs! In most cases a client will request a final product from a studio, and the process of creating that end product passes through the following hands, though not necessarily in the given order!

Job 1: Scriptwriter

The script is arguably the most important element of any production. If the script doesn't work, no amount of stunning visuals can make a good film.

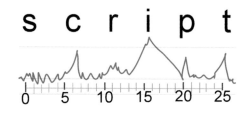

Job 2: Director and Story Artist

The script is laid out visually on boards that are finally agreed by the director. A storyboard and timed animatic – where the still storyboard images are sequenced in a movie with rough timings – can then be produced.

Job 3: Character Designer

Characters have to be designed at the start, once the animatic is made, to show the client. Those characters can then be fine-tuned for animation. Thought is also given to how they might look in the overall layout.

Job 4: Sound Engineer

Sound can be recorded before or after the visuals are finalised. The engineer looks after the technical quality of the sound. The timed track is split into several scenes and a track breakdown is produced. My example runs at 25 frames of image per second. However, this can vary according to the job in hand.

Job 5: Background & Layout Artist

Backgrounds are designed to create an atmosphere or style for the whole piece, and to show off the animation to advantage. Final decisions are made as to the best places to lay out the main animation.

Job 6: Key Animator

All the key positions of each movement in each scene are drawn. Drawings 1 & 5 are the keys here. No. 3 is the 'breakdown pose', with indication made to show how to get from one position to the next. Here the letter S is morphing into the letter C.

Job 7: In-betweener

Yes, you guessed it – all the drawings in between the keys are now produced. If drawn on paper, these are scanned into a computer (if produced via graphics tablet or a 3D programme the frames are already in the computer); from here they are all rendered into a movie file.

Job 8: Post-production

Once all the basic animation is created, post-production takes over to add special effects, both visual and, via the soundtrack, aural. At this stage fine-tuning is applied to both sound and images to bring the job up to the most finished state possible, before it is passed on to the client.

Computers have largely taken over from pencil and paper in the production of animation; however, the same basic jobs still exist whether you are producing work in 2D (hand-drawn) or 3D (computer-generated or stop motion).

Working as part of a group

The Filmfair studio was the largest I have ever worked in. The character in the image is based on the headteacher from Paddington Goes to School. My jobs were Nos 6 and 7 (as described on the previous page), with excellent direction from Ian Sachs. Once my drawings were done they were traced, coloured, cut out and stuck on card. The numbered card figures were then slotted into the set on which Paddington Bear, the stop-motion puppet, performed. It was a unique combination of both 2D and 3D animation. This aside, my group experience has been working with a small number of others or with single individuals. Although I like working alone I find that when I work with others my mind and my work expand. There follow two examples of this kind of collaboration.

1. Working with musician and singer Brenda Orwin

Up until 1973 the few test movies I'd made were inspired by a pre-recorded soundtrack. I then started sketching out ideas for a story about a boy and his cat, and, as I was used to starting from the music first, I asked my friend Brenda Orwin, who was a music teacher, to compose some music for me. I quickly realised it was no good just talking about my ideas; the only way I could communicate them clearly to her was to draw a series of thumbnails, with timings. I'd invented a storyboard without realising that this was standard industry practice!

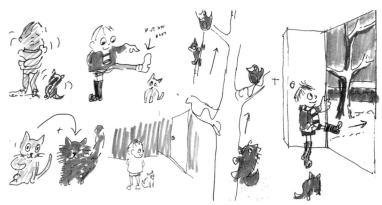

This is a clip from sheets of initial thoughts and jottings. Having to clarify that flow for another person meant I had to organise images and timings in a logical way. Thanks to this collaboration I went on to make The Boy and the Cat, the first movie that I felt actually worked.

Brenda is also a professional singer whose splendid soprano voice inspired me to have a go at a movie experimenting with animated action and lip-sync: *The Boy and the Song*, 1976.

2. Working with artist and writer Josephine Halbert

In 1998 I was approached by Josephine Halbert with a request that I animate her recently published book *When It Suits Me*.

Josephine's book provided the storyboard script, so I used that as my guide.

Initially it was a matter of timing Jo's guide track and then sequencing her images.

I was immediately taken with the witty storyline and sophisticated graphics, but also a little wary, as her style was so completely different from mine. However, thanks to the fact that I was now using computers for animation, as well as 'ye olde lightbox', I was able to catch the essence of her style and get it moving in a manner that suited!

Some parts called for a contrasting 3D CGI effect, so I called in my colleague Simon Auchterlonie to help.

Other sections called for extremely accurate flowing animation, so here fellow animator Ian Sachs did the legwork!

Once all 2½ minutes were completed, the late Dave Bainbridge provided a suitably ornate soundtrack that exactly fitted the lush oriental style of the piece. Leaving the soundtrack to be added later was a great freedom.

By scanning Josephine's artwork into the computer I learnt a lot about manipulating images and digital editing. It just goes to prove that group work can help you grow!

14 Contrasting Styles

1949 Chuck Jones and personal style

'As you develop any character, you are, of course, looking into a mirror, a reflection of yourself, your ambitions and hopes, your realisations and fears.'

Charles Martin 'Chuck' Jones, animator (1912–2002)

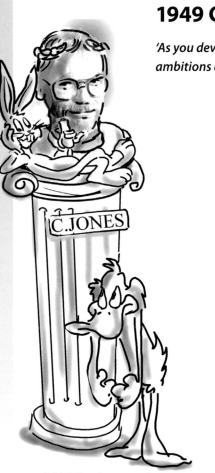

'I think therefore you are'
(with apologies to Descartes's famous maxim)

Chuck Jones was born in Washington State, USA. As a child he moved with his family to Hollywood, and often spent his time peering through the studio fence where Charlie Chaplin was making his films. His father did manage to find work in Hollywood, though it seems not to have amounted to much. In his autobiography, *Chuck Amuck*, Jones credits his artistic bent to the fact his Dad was an unsuccessful businessman: he would start every new business venture by buying new stationery and pencils with the company name on them. When the business failed, these were given to his children. So drawing was second nature to him.

After graduating from Chouinard Art Institute in 1932, Chuck held a growing number of jobs in the animation industry: animator, cartoon artist, screenwriter, producer, and director of animated films, most memorably of the *Looney Tunes* and *Merrie Melodies* shorts for the Warner Bros. Cartoon Studio. He directed many of the classic short animated cartoons starring Bugs Bunny, Daffy Duck and others. His biggest input was on character portrayal. Although he started from characters initially designed by others, he succeeded in making them his own. By 1950, Jones had redefined Daffy as a vain, egomaniacal prima donna wanting to steal the spotlight from Bugs, the cool, laidback winner. As he put it, 'Bugs is who we want to be. Daffy is who we are.' While that may be true, Chuck was still able to be a part of the studio machine while at the same time maintaining his own philosphy and distinctive style.

'Of all the Warner Brothers animation directors, Chuck Jones was the most philosophical, and thoughtful. In an interview that I conducted with him at a Cambridge Animation Festival, he would not allow me to describe him as "zany"'.

David Williams, animation historian.

Charles Boyer in the 1930s was a popular ladies' man, suave and sophisticated beyond women's wildest dreams.

In the 1940s and 50s, Pepe le Pew considered himself every skunk's dream.

Charlie Chaplin, the romantic little tramp of the 1920s.

One character who was all his own was Pepe le Pew, though he was supposedly based on film star Charles Boyer, a French Casanova. Pepe was an amorous skunk who won an Academy Award for Chuck (and Warner Brothers) in one of his first appearances, in *For Scenti-Mental Reasons* (1949). Pepe portrayed elegant and subtle emotions through his gestures. I don't think it is a coincidence that they not only hint at the character of M. Boyer, but they also reflect the silent movie gestures of Chaplin, an artist Chuck admired all his life. However, the wild changes of pace and razor-sharp timing come from deep within his own personality.

'When I met Mr Jones for his 85th anniversary, he reminded me of the old man in Jurassic Park. I thought to myself, "Spielberg probably used Chuck Jones as a model for that character." He had the cane, the hat and everything. Mr Jones was very dignified.'

From ASIFA- Hollywood: Animation Archive.

Contrasting styles

Chuck Jones spoke out strongly on the fact that 'we draw what we are'. The British Film Institute had entered one of my films into a festival in Greece. As a free ticket went with the screening, I flew over at once to Thessalonika. In my pigeonhole at the hotel I found a note inviting me for a coffee. It was signed, 'Alison de Vere'. 'Wow!' I thought, as I had just seen her *Cafe Bar* screened on TV the previous week and had thought it was so original and moving.

Alison was half the size I expected, very unassuming, with a gentle Cockney accent that contrasted with my Geordie one! Over coffee she described a dream she had just had, involving a black dog and a journey. Years later, on TV, I saw that dream transformed into the award-winning film *Black Dog*.

Alison worked on epics like *2001: A Space Odyssey* and *Yellow Submarine*, as well as countless commercials, but she was unique in her ability to fit the production of her own personal work within her busy schedule. She introduced me to the professional world of the London studios. Moreover, in the time I spent with her in her small Kensington Church Street flat, I discovered how her magic movies grew from her own personality and life experience. I have chosen two out of the many she produced.

Cafe Bar, 1975. *'I have tried to show the problems of communication between men & women.' Alison de Vere*

The Cafe Bar was one she knew. There she is sitting in the corner, putting on a brave face and being dive-bombed!

This intrepid little figure, battling the elements, to me embodies Alison's spirit. Whatever life threw at her she went on to fulfil her destiny.

'I was not alone in the love and respect I held for my mother. Alison was possibly one of the most powerful thinkers and at the same time one of the most gentle and humble people I have ever known. Once asked in an interview during the early days of the Women's Liberation Movement if she was a sex warrior, her reply was 'No, I am a sex pacifist'. Her inner strength and her humility were awe-inspiring to me, both as a child and the man that I grew into. With her trademark economy of line and command of mime and gesture, the understated mystery of her films contained layer upon layer of meaning. Often using a caricature of herself as the fool, she took us to unguessable places with grace, tenderness and wonder. She was a visionary film-maker and a truly marvellous person – everything she did was magic.'

Ben de Vere Weschke, Alison's son

Mr Pascal, 1979. *'I always hated the idea of the figure nailed to the cross, and wanted to get him down from there.'*

Alison de Vere

Mr Pascal looks wary as he pulls out nails from the feet of the crucifix in Kensington Church Street.

A typical 'Should I really have done that?' expression from Alison.

Spot the twinkle in the eye of the liberated and 'warmed-up' Christ figure.

When Alison did smile it was a flash of sunshine, with a definite twinkle.

In direct contrast to Alison, but equally creative, I must mention Bob Godfrey. His 1970s DIY Film Animation Show, which appeared on the BBC, encouraged me and many others to animate. His variety of styles grew partly from limited budgets and partly from a concern to suit the style of animation to the point being made.

This is a compilation of Bob's images by me – an attempt to get inside his complex personality.

'I just happen to like to making people laugh. If I wasn't in animation I'd probably be in a seaside concert party.'

'Animation deals with the surreal, the impossible – there are no limitations. The only limits are within the animator themselves.'

Bob Godfrey

'Bob's unique style is partly based on the fact that he is really an actor rather than an artist. Unlike many animators who hide behind their drawings, Bob presents himself through them, and is close to the oldtime music-hall turns where the actors always faced the audience. In Henry's Cat I asked Bob not use round eyes, and never to have him in profile, so as to retain full-face contact with the viewer. This requires body language more than facial expressions, so Bob used his acting skill. His sense of timing was perfect, and timing is unfortunately something that is rarely taught in animation. I advise animators to act out their scenes, and where possible to film and review them. He was not particularly interested in styles as such – it was always the statement. He was never trying to change the world through his work but to see it through the innocent eye for all its frailties. He retained the child's view of the world which undermined pretentiousness.'

Stan Hayward, scriptwriter

My style

As I taught more and more folks of all ages, it was clear to me that what they drew was what they were. In a special-needs animation workshop in 1978 a young adult had made a figure out of plasticine. Her teacher exclaimed, 'She is always drawing them!' Your style is not just in what you draw, it's how you build, how you dress, how you decorate your house. Everyone is an artist if allowed to practice their art their way.

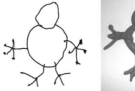
The drawing

The model

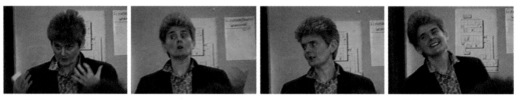

In 1985 I saw a video of me lecturing to students and thought, 'I animate like that!' Sort of jerky and a bit manic, dodging about a lot hopefully to keep the audience awake!

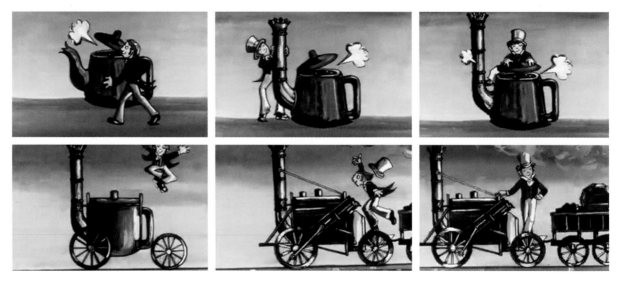

This series of stills is from the film *Moving On*, made in 1976, which tackles the history of transport. We see George Stephenson observing how a kettle lid bounces with steam generated from boiling water, which leads to his invention of the first steam locomotive. That information takes about 10 seconds to read. Animation shows it in half the time! My Mam always said my animations were far too fast and jerky. True, I thought, but at least the viewer won't have time to be bored! She also said I came downstairs like a 'fairy elephant', but that's another story...

The Boy and the Cat, 1973	*Face to Face, 1980*	*Best Friends, 1983*	*Me in 2008*

Looking at the shape of faces I have drawn just 'out of my head', and not from another person's work, I see they are the same proportion and shape as my own face. Check yours out!

It has also followed that when I have managed to make a film of my own, rather than for a client, I have followed my own surroundings and personal experience.

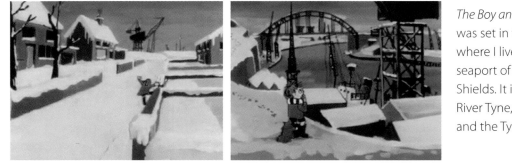

The Boy and the Cat was set in the street where I lived in the seaport of South Shields. It included the River Tyne, its cranes and the Tyne Bridge.

In *Lifeline* (2002) I set out to include only surroundings I knew. At the end of the movie the backgrounds change from city to countryside. At that time I had no thoughts at all about moving. Now I live in the depth of the country in southern Ireland. Maybe your movies can influence your future by putting new possibilities into your head!

15 Pixilation

1952 Norman McLaren and pixilation

Norman McLaren (1914–87) attended Glasgow School of Art, where he was inspired by the films of Émile Cohl, Oskar Fischinger and the Russian expressionist Sergei Eisenstein. Thereafter his work fell into two main groups: those that explored both abstract and figurative imagery and music for their own sake; and those that sought to express his deep hatred of war. In 1941 John Grierson phoned him offering him $40 per week and a promise he could make films his own way if he would run the animation department of the newly formed National Film Board of Canada. He accepted the job and went on to create some of the most innovative animated films of the 20th century.

The two images shown give a glimpse into the public and private sides of McLaren's brain. In one, he is pictured in 1949 at the NFB, painstakingly painting directly onto blank film. In the other we see his self-portrait from 1946, drawn 'behind the scenes' after completing a job on map projections. He remarked at the time, 'I built a stereoscopic viewer with 24 in. between eyes (instead of the usual 2½ in.). I would look at faces close up, with my eyes two foot apart. The effect stunned me.'

The process of pixilation is attributed to him; that is, taking single-frame pictures of human movements to produce impossible or fantastic sequences. His anti-war movie *Neighbours*, made in 1952, shows the unique strength of this method of animating to create attention-grabbing effects.

The headlines read: 'War certain if no Peace' and 'Peace certain if no War'.

The neighbours turn as a brightly coloured flower 'pings' into view.

At first they are both delighted by its beauty. Pixilation makes levitation easy!

Then boundaries are drawn up as each fights for ownership of the bloom.

They destroy the other's house, wife, baby and finally each other.

The fence posts animate to enclose the graves, each of which ends up with its own flower!

Although it won an Oscar, the film was considered so shocking that the infanticide sections were cut, while in some countries the film was banned altogether. It seemed the world was not ready to take animation with such a serious message. Although initially one of the main reasons why McLaren animated at all, it seems he never again made any 'dark' films, preferring to concentrate on his lighter, fun-packed, poetic side. This reminds me a little of Walt Disney, who in *Fantasia* so wanted to make a deep statement about classical music. Once it was rejected by the public he never went there again, putting his creative energy instead into designing Disneyland. I would like to think that students (of whatever age) reading this today might continue with their dreams, unhindered by public opinion.

Pixilation

McLaren used a film camera on a tripod to create pixilated movies. The advantage of a film camera is it allows you to take a single frame at a time, with each second of action usually comprising 24/25 individual frames. This means you can create very accurate pixilation with the camera, whether you are using 35 mm, 16 mm or Super 8 film.

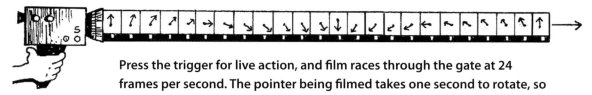

Press the trigger for live action, and film races through the gate at 24 frames per second. The pointer being filmed takes one second to rotate, so this simple movement is recorded in 24 separate frames.

Press the single-frame release on the camera and only one frame of film is recorded.

Nowadays, the more expensive digital movie cameras will allow you to take single frames that can be run back as a complete movie. Or by hooking your camera up to the appropriate software you can grab action in single frames to build a movie.

If you just possess a bog-standard digital camcorder, there follow two examples of how to use it for pixilation. You will also need a computer that runs a simple editing programme.

This example was the first go at pixilation by an animation student of mine. The brief was 'your daily routine in one minute'. A cup of coffee was central to her day, so that's what she used!

Working alone, she set her camcorder on a tripod and pressed 'record'.

She then proceeded to act out the business of chasing an elusive cup.

The whole film was edited on computer. Only frames needed to create a pixilated effect were left.

It's best to have a static background if possible. In this shot the trees waving in the wind are highly pixilated too!

This second example was shot by me using my colleague Jen as the pixilated model. Once she was in position, assuming a driving action, I shot a short burst on the digital camcorder, stopping after, say, half a second. Jen then took a step into the next driving position and I took another burst. On playback the action is pixilated but jerky. For best results put the movie into the computer and edit out the frames that are holding up the action.

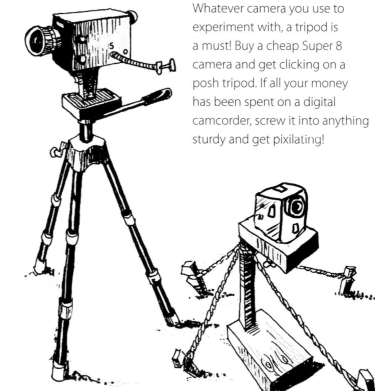

Whatever camera you use to experiment with, a tripod is a must! Buy a cheap Super 8 camera and get clicking on a posh tripod. If all your money has been spent on a digital camcorder, screw it into anything sturdy and get pixilating!

Pixilation

When I began playing with the single-frame release of my Super 8 camera, back in 1970 (see pages 104–105), I tried clicking away at everything that moved: a candle burning down, one frame per minute; Clouds rushing across the sky and my mother crocheting, both shot at two frames per second. As I continued with my hobby I thought the secondary-school children I taught would just love this. I started a cine club after school. At that time the idea of pottery classes was still avant-garde, never mind cartooning! It was the children who opened my mind to all sorts of possibilities with this new-found medium. Concepts that had taken me weeks to grasp they latched onto in seconds, as you can see from the pixilated action of a whole class orchestrating themselves. Remember there were no videos or computers in general use at that time. This was the first time we had all had the chance to express ideas and learn through having fun with the animation. We knew it would catch on! Apologies for the poor quality of the Super 8 images – they don't transfer well!

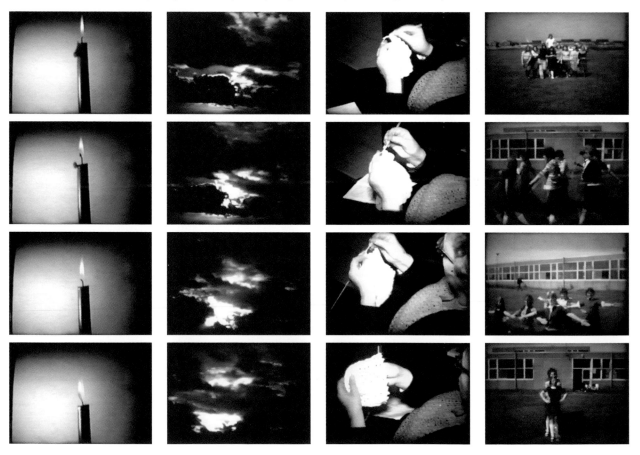

Later I moved away from pixilation into drawings and cel animation. However, when I had a go at animating *Dance Macabre*, mainly in stop motion, I decided to pixilate the devil's hand. In part of the movie he is drawn on cel, but he had to be 3D to interact with the model ghosts and witches. I reckoned that rather than make a whole hand it would be easier just to paint my own and add green plasticine nails. So I did, grabbing the characters with one hand and clicking the camera with the other. Of course, the doorbell rang in mid-film; I'll never forget the double-glazing salesman's face when I answered the door with my devil's hand – he didn't wait for an order!

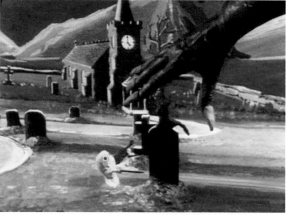

So pixilation can save a lot of modelling and drawing, and can be dead interesting too! You can use a still camera and drop all the single frames into your computer to run them. Or if your camera is fancy enough, it may run them as a movie if you hold down the playback button.

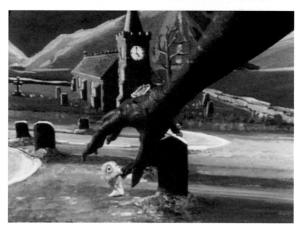

16 Cosmic View

1968 Cosmic zoom

Eva Szasz, another formidable animator who worked at the National Film Board of Canada, drew a series of still images which were then shot on a rostrum camera. Through continual zooms and mixes we are taken on a journey into deepest space and then back, into the tiniest part of an atom. This selection of images tell the main story.

The eight-minute film opens with a live-action boat being rowed by a boy on a lake near Montreal in Canada. The action freezes and the zoom out into space begins. Once we reach the farthest limits of the macrocosm, the action zooms back in quickly to the boat, and continues to zoom in, revealing a mosquito on a boy's hand and then the cells, molecules and ever smaller microcosms that all life is made of.

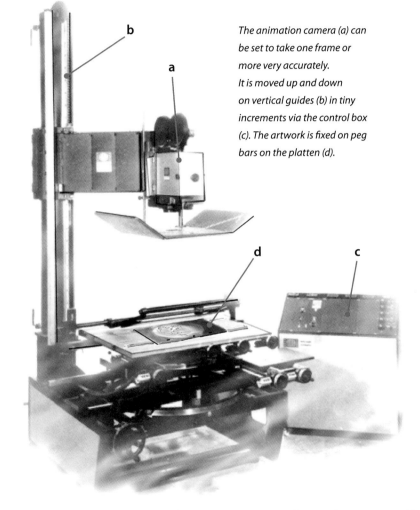

The animation camera (a) can be set to take one frame or more very accurately. It is moved up and down on vertical guides (b) in tiny increments via the control box (c). The artwork is fixed on peg bars on the platten (d).

Peter Neilson, joint founder of the English animation equipment company Neilson Hordell Ltd, told me one of his own rostrum cameras was used to make this film. The camera could zoom in and out with amazingly smooth precision, but to prove its effectiveness it was thought that an animated film based on the book *Cosmic View* by Kees Boeke, with its clearly planned images, would be a good way to put the machine through its paces. They were right. Eva Szasz proved that it is possible to create an 'animated movie' simply by zooming in on a series of stills – though a good script helps!

The concept has been copied many times since in films such as *Powers of Ten* by Charles and Ray Eames, made in 1977, and Bayley Silleck's 1996 film *Cosmic Voyage*, made for IMAX screens. However, trust the NFB to get in there first (see page 102). Their remit is to create original, thought-provoking, educational films with an entertaining twist. This film is certainly all that and a bit more!

Cosmic view

Due to lack of space on page 108 I cut down the number of still images taken from the movie to 20. There should have been 40. This number is not at all arbitrary; it is the number of images arrived at by Dutch educator and pacifist Kees Boeke in examining our universe. On reading the book *Cosmic View, or the Universe in 40 Jumps* I was knocked out by the amazing thinking behind each image. Up to now, in this section I have talked about techniques, but I think it legitimate to use this space to talk about the mathematical technique that he used to explore our universe. It's one that he advises teachers to try with their students to 'stimulate their initiative'.

> *'Certain objects are first drawn on the scale 1:10, together with part of the room in which they are situated. In the next drawing this room is shown with the school building around it on the scale of 1:100. Then, at 1:1000, the school building is drawn with its surroundings, and so on: the town or county, the district, the state, the continent, the earth. By then the significance of scale will be sufficiently grasped, and the pictures in this book can be even more clearly understood.'*

Kees Boeke

I can only understand mathematical concepts like this by actually doing it, so I had a go.

I drew a 15 cm (6 in.) square. The figure in real life would be 150 cm (60 in.). So the proportion is 1:10, or 1 cm in the drawing = 10 cm in real life.

In a 15 cm (6 in.) square I drew my room, which is 600 cm x 450 cm (20 x 15 ft) as a box 6 cm x 4.5 cm (4 x 3 in.). The scale is 1:100, or 1 cm in the drawing = 100 cm in real life.

Always using a 15 cm square, I next drew my surrounding garden. The conifers are 1500 cm (50 ft) high, so they come out at 1.5 cm on a scale 1:1000.

The trick is to add a nought. Here we are at a scale of 1:10,000. I am now looking down at my garden from 5000 m (16,400 ft) up – as high as Mont Blanc!

It took me a while to get my head around it. Once I did, the whole idea slotted into place. Using his method you can indeed take a measured wider view, and in reverse, by using minus measurements, a smaller view!

This is my version of a Kees image drawn to 1:1000 scale. It shows his U-shaped school building, *'De werkplaats'* (the working place), converted from a building constructed by the German military during the occupation of the Netherlands.

The small orange square shows the previous area viewed at 1:100; and in the centre of that, the black dot, sits one of his students and her cat! To the right of the image is a 150 cm (60 in.) ruler used as a guide with all 40 images in the book.

Boeke studied at the Delft University of Technology. He later married fellow Quaker Betty Cadbury. Together they worked for many years in international peace movements. Later Kees decided he could help society more by teaching children, so in 1926 he founded his school, which used Maria Montessori's methods. It became famous; even the Dutch queen sent her daughters there. The school was hugely influential for its creative way of making the students co-responsible with the teachers for their own curriculum. Many students who failed in regular schools blossomed in this one. I think there are cosmic lessons for us all here. If we arrive at a global view, it might just help global understanding and maybe stem the tide on global warming, too. Who knows!

*Kees Boeke
(1884–1996)
in 1939*

Cosmic views and zooms

I first saw *Cosmic Zoom* in 1970 or so, along with many thousands of others, on the children's TV programme *Blue Peter*. There are two reasons why it made a huge impression on me. Firstly, it was visually stunning, in fact hypnotic. Secondly, I thought, 'I'm not alone – it's not just me that thinks we are all part of life's rich pattern.'

When I was at secondary school in the early 50s, I was lucky enough to be allowed to study both art and science at A level, which was quite unusual in those days, though happily times have changed. It meant that in the course of a week I could be drawing both the exterior of a plant in art lessons and its interior view in biology class.

Chrysanthemum, pencil, 1956

Tulip stem, pen & ink, 1956

One of the best all-time Christmas presents I received in my teenage years was a microscope. With this tool I examined everything from a drop of dirty rainwater to my own blood. Wherever I looked there were new worlds beyond what met the eye.

Vorticelli – tiny organisms found in pond water.

Blood corpuscles.

South Shields Marine and Technical College had a planetarium run by an amazingly informed expert named Eva Hans. Not only did she know her stuff, she could also put it over in a clear, fun way. She ran a hugely popular club for youngsters, for which I helped design a series of badges. In meeting with Eva I got to see, and partially to understand, the wonders of the universe first-hand.

'What does the milky weigh?'

'Give me a ring'

I first started to get my head around all this when I was 21. My final thesis at Birmingham was entitled 'Art, Science and Life' – and this was before I'd read *The Hitchhiker's Guide to the Galaxy*. In my researches I met a book by Gyorgy Kepes (1906–2001), *The New Landscape,* which was published in 1956 and began as part of his thesis! An artist himself, he was a professor at the Massachusetts Institute of Technology, which is famed for its search to find unity between science and the humanities. His concepts were influential in describing the principles of the Bauhaus, some of whose founding members taught with him at MIT. Reading his book (and looking at the pictures) was like coming home, and I've pursued that journey ever since.

What we meet in our teens often colours the rest of our lives. What have you met so far that interests you? Can you imagine that you will still feel as strongly about it when you're 68? You'll know one day!

'The universe is not to be narrowed down to the limits of understanding, which has been men's practice up to now, but the understanding must be stretched and enlarged to take in the image of the universe as it is discovered.'

Francis Bacon

After seeing my film *Leonardo* the late Peter Neilson gave me one of his rostrum cameras on 'indefinite loan'! He asked me never to tell anyone it was 'for free', as they would realise he was not the hard-headed businessman he might have appeared to be. He was, in fact, a bit of an all-round genius himself. A gifted engineer, I remember him, just for fun, building an aeroplane in one of the rooms in his house – I hope it got to fly. I certainly did, thanks to his generosity, and tackled several subjects I might not otherwise have managed, thanks to the 'cosmic zoom' of the rostrum camera in my living room.

17 Stop Motion Animation

1970 Will Vinton and claymation

In the early 1970s Will Vinton invented his own form of 3D animation, which he called 'claymation'. He had enrolled at the University of California, Berkeley to study physics, architecture and film-making, and was particularly fascinated by the sculptural shapes of Antoni Gaudí. This love of surreal 3D shapes can be seen clearly in his first clay animation, *Closed Mondays*, in which a drunk enters an art gallery and interacts with the exhibits. One of them is a computer sculpture that goes into information overload!

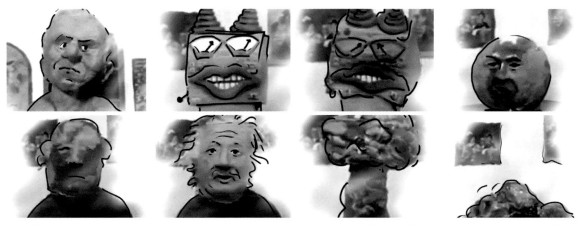

This film won the Best Animated Short Film Oscar in 1975, from which point he was set up for the rest of his distinguished eye-catching career in short and feature films and in television commercials and programmes. He is probably at his best when being totally unpredictable and allowing the clay to be clay. However, he can be more restrained and 'realistic' when required. Here he demonstrates the basic technique of making an armature covering it with clay and animating frame by frame on a handbuilt set.

Peter Lord and Dave Sproxton introduced the very popular character Morph to British television in 1977, whilst they were still sixth-formers. They first contributed short clips to *Vision On,* a really groundbreaking programme aimed at both deaf and hearing audiences, and from this success Aardman Animation was born.

The subsequent recruitment of Nick Park and many other talented stop-motion assistants put them at the top of the league and has led to the company gaining more Academy Awards even than Will Vinton. However, though claymation and model manipulation may survive in short commercials and independent movies, in the last decade even Aardman, having travelled from *Morph* to *Wallace & Gromit* to *Chicken Run,* has moved to CGI for some productions. This is because more and more precision is needed for the time-consuming activity of animating solid figures in a realistic way.

Maybe 'claymation' will stop being so 'real' and return to its surreal roots, such as in this composite image from one of Vinton's films, in which his face is animated through various transformations until it finally explodes 'back' into a lump of clay. Watch this space!

Stop-motion animation

Using stop-motion with clay can be one of the most complex, or one of the simplest, ways to animate. Here are three ways to help get you going!

Scenario no. 1

Working with a group of 15 youngsters sharing a single camera linked to a TV monitor, this workshop lasted one hour. Each student had a lump of clay and made their own monster, then plotted three stop-motion moves in front of the camera. The results are on the DVD.

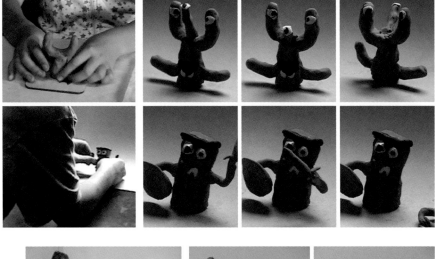

Scenario no. 2

Here I am working with foundation students, animating in groups of four with one normal digital movie camera on a tripod. Given two completely different phrases at random, the brief was to put them together to make a story. Here the words were 'Ginger the cat' meets a 'bottle of vodka'. The group had three days to plan a storyboard, make sets, animate their models and add a soundtrack.

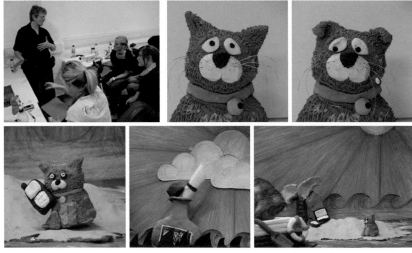

Ginger the cat is lost, and we empathise at once because of the excellent model. He tries to 'phone home' from his desert island, but there's no signal. His laptop comes up with an 'error' message. Driven to drink his bottle of vodka, he thinks 'message in a bottle'. It works! As does the simple but effective stop motion, as you will see from the clip on the DVD.

Scenario no. 3

Animation students on their BA course had been set a brief to animate an artist of their choice, over a period of three weeks. Here the group of three have chosen Salvador Dalí. After the script was agreed by all and a storyboard drawn up, jobs were allocated.

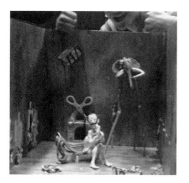

One student worked on set design, which in this case resembled a dull, stark prison cell, creating the illusion that Dalí was trapped inside his own mind with his creations. The lighting was neutral until one of the students tripped on a flex and pulled the plug on one of the lights, which inadvertently created a much more dramatic atmosphere that the group were sensible enough to embrace.

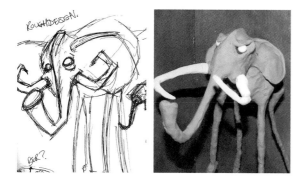

A second job was character design. Many sketches were made and all was agreed by the group before the final sculptures were tackled. Armatures were made from wire and characters built up in clay. The strength of the wire was vital to keep some characters upright, and its flexibility was also necessary to enable Dalí to wave his arms expressively in his straitjacket without them dropping off!

The third person worked the camera, which was plugged into stop-motion software on a PC. Every frame shot was put directly onto a timeline. It was felt that the action would have been more fluid shot on ones rather than two frames per image. Have a look yourself on the DVD and see what you think! You can also hear some of the highly effective soundtrack that was dubbed on after shooting and editing were completed.

Stop-motion animation

I had tried stop-motion in sections of films such as *Dance Macabre* (see page 107) and *Expressionism* (see page 34). However, it was not until I was approached in 1982 by Nerys Johnson, Keeper in Charge at the Durham Light Infantry Museum and Arts Centre, that I tackled an animated film which relied mainly on stop-motion. Henry Moore Head-Helmet was a DLI exhibition held to celebrate the 150th anniversary of the founding of the University of Durham, and I was commissioned to make an animated film based on the works of Moore that were on display.

'Great,' I thought, then after a look at the exhibits as they emerged from their packing cases, my thought changed to, 'How on earth can I animate Moore's solid, monumental works?'

Henry Moore with one of his bronze Helmet Head sculptures.

At this point Nerys opened up a tea chest and said 'Look'. Inside were a heap of bones, flints, shells and pebbles. I picked up a flint with a gloved hand. 'Feel it!' said Nerys. So I did, carefully; it was smooth and warm, like a human being. On it were Moore's pencil marks, suggesting where eyes might go. Good God, there in the palm of my hand was a future 30-foot-high Moore sculpture!

Moore at work in his maquette studio, 1979.

'I like this little studio. I am always very happy there. I like the disarray, the muddle and the profusion of possible ideas in it. Within five minutes I can find something to do which may get me working in a way I hadn't expected and cause something to happen that I hadn't foreseen.'

Henry Moore

So now there was a glimmer of a possible route, I began exploring in the usual pattern I follow when making a film. I explored and drew, and whilst sketching wrote down words and phrases that came to mind. Anything at all. At this point my mind is just a blank canvas (well, it usually is anyway) on which, with a bit of luck and a lot of research, a concept for a movie will appear.

This is one sheet of many where I got in touch first-hand with the 'small interior' side of Moore. The Head-Helmet show led me to concepts of 'huge hard outside' protecting 'small soft inside'. I got as far as thinking I could shoot the hard outside of Moore's exhibits as live action, but how could I show the 'softer' thinking process? The eureka moment came when I realised it could be shown by working with stop-motion clay animation superimposed over the 'real thing'. A wooden turntable made by the DLI technicians helped hugely, particularly as they turned it themselves!

My clockwork 16 mm Bolex and I shooting Henry Moore at the DLI.

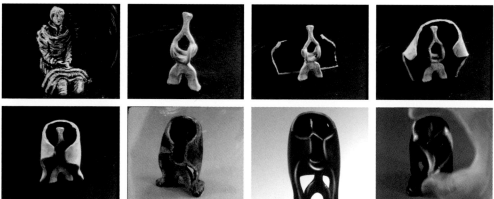

This section from the movie shows how stop-motion helped to create the feeling I was after. It starts with a stop-motion chalk drawing I did from one of the tube-station images Moore made when he was a war artist. This vulnerable figure dissolves to one created from clay. A protective sheet of clay is animated around the figure. Once in place the whole is painted to look like the bronze *Helmet Head*, then we mix into the original sculpture. The movie dissolves onto a shell, with similar 'inside/outside' shapes held by a hand. This leads us into a section about handling small found objects – which is where his creations all began!

18 Computer Animation

1974 Peter Foldes and the first computer animation

Death and disintegration haunt the films of Peter Foldes, who was born in Budapest in 1924. He studied fine art at the Courtauld Institute and the Slade School of Art in London. In 1956, John Halas of the Halas and Batchelor Animation Studio encouraged him to make the film *A Short Vision*.

The film was sandwiched between ventriloquists, singers and jugglers on the Ed Sullivan Show. It was so chilling that the studio audience sat in stunned silence when it was over. Wires and phone calls poured in, about evenly divided between praise and condemnation. The 'question of the week' in *Animation Magazine* dated 31 October 2007 was, 'We all know animation can be funny, but it can also be very scary. What cartoons gave you the willies when you were a kid?' Many online answers quoted *A Short Vision*, and they tell the story far better than I could:

'It's a parable about nuclear war, faces turn to skulls. I saw it as a boy in the late 1950s. It still haunts me,' says one, while another insists, 'I saw it when I was 10; it terrified me. Years later I met a young man who had a patch of grey hair growing on the top of his otherwise dark-haired head. He told me that he saw the film by himself when 6 years old, and from that day onward his hair grew out grey from the top of his head. Evidently his condition was one of the few medically verified cases of hair turning grey out of fright.'

Despite great critical acclaim for this film and other work, Peter and his wife Joan moved to Paris in 1956. Here he painted and animated until, in 1971, he was invited by the NFB in Canada to work on *Metadata*. These two stills give a flavour of the style.

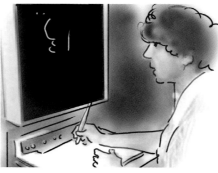

Foldes's style was quite linear anyway, but in this film the line has grown much sharper and cleaner. This is due to the fact he was using the world's first 'graphics tablet', as in this photo taken in 1971. It was plugged into a computer-assisted 'key-frame animation' system that imitated conventional cel animation. It housed a then-phenomenal 27K of core memory! The system was developed at Canada's National Research Council, which is famed for its groundbreaking discoveries in computer-animation technology.

Foldes, however, was dissatisfied with **Metadata**. As technologies improved, so did his work. In **Hunger** he really got his act together, declaring, 'I choose to use the computer because this is the animator's new frontier.' In it, all the key frames were rotoscoped from live-action footage and then the computer was used to calculate the 'in-betweens'. These two sequences from the movie show how effective this method was – indeed, so much so that it received an Academy Award nomination in 1974, only to be beaten to the actual Oscar by Will Vinton's **Closed Mondays**.

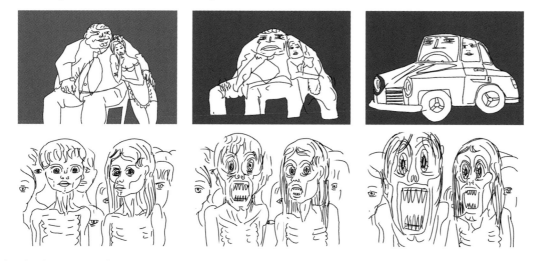

Foldes died in 1977, before the completion of a planned feature film. Only one section of **Au delà du temps** (Beyond Time) survives. But his faith in the new technology influenced many other animators.

'The art of the 20th century is cinema. With a computer I can make metamorphosis, but with greater control over each line of the drawing, I can move as I please. But the machine does not create anything, it only does what I tell it to do.'

Letter from Peter Foldes to Giannalberto Bendazzi, 1973

How computers can help you evolve

In a small room at a local college, leading off from a main studio that was full of lightboxes, I worked with a suite of nine Apple® Macintosh® computers hooked up to one printer. Here I taught Adobe® Director® 4 to animation students in the early 90s. My current version of Director® is 10.1, and most animation courses have their main rooms full of computers, with the smaller spaces allocated to lightboxes. Why this huge role reversal in under 20 years? One reason, I suppose, is freedom. 2D computer software offers a wide range of stylistic possibilities beyond those easily arrived at with a pencil and paper. A good example of this can be seen in the following work of this University of Sunderland BA student.

After a good grounding in basic animation principles, by drawing on her lightbox this student now tackles a short piece using Flash®. This software lends itself to simple, bold outlines, flat colour and computer-game action. Here it's *Vinnie Versus the Fly***.**

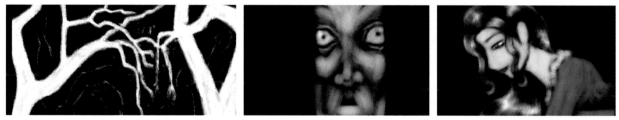

For her final BA project the same student chose Corel® Painter™ to illustrate the poem *The Highwayman***. The line now is softer and the backgrounds atmospheric. A totally different style has emerged, well suited to this totally different subject.**

The same student moved on to take an MA. A keen observer of nature, her store of close-up photographs inspired her *Avatara* **to take us on a journey around her own 'backyard'. The humour of** *Vinnie* **is now combined with the poetry of** *The Highwayman***. Continuing to use Painter™, she explores new levels and effects to portray her inner and outer vision of the world.**

Another reason for using a computer is it can save time, leaving more hours for experiment and innovation. Here the brief was to add digital effects to a live-action piece. Animation was chosen as the 'effect'. Using film, this would have meant two closely coodinated shoots, one live, one rotoscoped animation (see page 60) 'A & B' rolling them at the lab (see Glossary), which is both expensive and time-consuming. If alterations were needed to the final 'married print', that would have meant a lot of time and extra money too.

After Effects® and Flash® were used to animate the scribbled characters. The live-action footage and the animation were then put together in an editing package. Extra layers and masking made it possible to weld all the action into one very effective movie. The soundtrack enhances the crazy action and the creative use of technology makes it fun to watch.

With digital technology the whole process is a lot quicker and cheaper! The storyboard and initial script were planned and then agreed by the group of four who co-directed the entire project. Scribble Kid is making Mr Moogan's life a misery by constantly messing up his street. Even after being cleaned off the characters fight back and go on to have a life of their own.

Overall production time from start to finish for the three-minute movie was 90 days. To quote one of the team: 'It was a very very stressful project, but worthwhile all the way and very, very, very enjoyable.'

I reckon that sums up digital animation. The stress is often caused by the computers themselves playing up, but the continual surprises inherent in the production process as well as the thrill of seeing it all finally come together make all the blood, sweat and tears worthwhile!

How computers have helped me evolve

Like Peter Foldes I started out as a painter, turning later to analogue then digital animation; although my work has not, as yet, turned anyone's hair white overnight. In 1985, in my job as a media adviser, I came across BBC computers in schools for the first time. Even entering text at that time was tricky. The top artistic achievement I met was one teacher who had a trolley holding screen, keyboard, mouse, hard disk, printer, digitiser and camera. With this set-up he grabbed in a still of a face, which could then be manipulated very simply via the computer and printed out. This was considered to be a breakthrough at the time. Every secondary school in our LEA bought a trolley and all the bits!

The first computer I bought was an Amstrad. I liked it because everything was in one unit and it came with software that actually enabled me to draw with a mouse – wow!

A print out of my face using the BBC 'trolley' set-up.

By 1989 graphics tablets had become available. I could afford (just) the £1000 price tag for an A1 Wacom tablet with pen, plugged in to my Apple® Mac® computer. Most software was aimed at still images so, using Painter™ I drew stills. We produced a series of books for hospitals and social groups using a rotoscope technique that was perfect for portraying sensitive subjects.

However, there was one program out there that was about to change my life. Adobe® Director™ enabled the 'end user' not only to draw but to *animate* on a small computer like mine. The lines were jaggy and bitmapped but they moved, instantly – magic!

Using the A1 graphics pad with fellow director Jen Miller.

An early image drawn in Director™.

Why Did My Daddy Die?, designed to help children deal with death in the family.

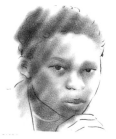

HIV Let's Talk helps families share concerns about change and loss.

1991
TTTV series Powerhouse.
Here I had the chance to animate wacky graphics over films chosen from TTTV's archive – great fun!

My film camera was for broadcast jobs and the computer for play – that was until TTTV's Trevor Hearing approached me to create inserts for Powerhouse, his series on North-east inventors. Animated in Director™ over bluescreen at home, then 'keyed' over live action at the Tyne Tees studios.

1994
Splat, an interactive history of art.
This is my pilot for a project I'll finish one day! Thanks to interactivity the end-user can explore and get involved in watching and making art.

Later I discovered the Interactive Side of Director™. Beginning with a job at Interactive Learning Productions, where I helped to create animation for one of the first 'edufun' CDs for children in the UK, I went on to create many others for educational purposes.

1995
Scat the Stringalong Cat.
Real string could not be animated to create the subtle characters required. Pencil lines did not have the right texture, so what to use?

My colleague Ian Sachs had been given a commission by the BBC to make inserts for a Playdays series. His animation had to resemble a piece of string on the move – an ideal subject for bitmapped animation!

2002
SignPost website.
The site was started by fellow animator Scott Tyrell. I then worked closely with artist Nikki Green, who being deaf herself really knew what sort of layouts to go for!

Bob Duncan from SignPost (the British Sign Language unit for deaf people at Tyne Tees TV), invited me to work with the team to help design a very visual website. I learnt a lot about how to keep animation files small but effective, and quite a bit about signing.

2004
Tyne Cargo.
Compare the pace and character design of this film with Moving On (see page 100). It just shows that whatever materials you use, in the end your own style emerges!

Thanks to many different jobs I had gained the computer skills I needed to make animations for broadcast TV, interactive CD-ROM and websites. Moreover, my Mac was now powerful enough to run 'anti-aliased' or 'non-jaggy' animation. So in Tyne Cargo (see pages 28–29) I could at last animate with no technical limits!

19 3D CGI

1986 John Lasseter and 3D CGI

Luxo Jr. (1986)

The entry of John Lasseter into this history of animation represents the opening stage of the CGI (computer-generated images) revolution. When *Luxo Jr.* was screened on TV in the late 80s, very few people could work out how it was done. Now CGI is a household word. Films like *Toy Story*, *Shrek* and *A Bug's Life* are amongst the best-known movies on the planet. That all this has happened in just over 20 years is mainly due to the vision and energies of one man – John Lasseter. He is now hailed as the second Disney, not only because he is a crucial part of the Disney Empire but possibly because, like Walt, he can tell a good story.

Red's Dream (1987) tells the story of a small red unicycle. It opens on a dull, wet street, then pans into a darkened bike shop, where tucked away in bargain corner is Red. Why do we feel sorry for him already? The setting, the ambient sound, the sad angle at which his little frame leans away from us – between them they say it all. He cycles into centre stage and remembers when he was a star turn with the circus. We hear the laughter, see the lights, watch him juggling masterfully. Cut back to reality as he trundles back to his corner and bangs his 'head' against the wall. He has neither a head nor a face, and yet the film portrays huge emotion. When I saw it I cried, and I still do. You can understand why Lasseter once remarked that Disney's *Dumbo* was his favourite film. I cry at that too!

Tin Toy, also directed at Pixar by Lasseter, tells the tale of a destructive baby and a nervous wind-up toy. This short made history as the first computer-animated film ever to win an Academy Award. The subject sprang from Lasseter's love for toys (he still has his entire Hot Wheels car collection from childhood), which was taken to greater heights with *Toy Story*. The 2D drawing of the hero of *Knick Knack* reminds us that Lasseter spent four years learning the craft from Disney's masters of the medium. His great genius was to combine the character and timing of 2D drawn animation with the 3D appeal of CGI – plus a darned good storyline.

Knick Knack (1989)

Tin Toy (1988)

Lasseter's mother was an art teacher, and he is a graduate of the California Institute of the Arts. The story goes that as a young man he noticed a lamp on a desk in a window display and told his mother of an idea he had to make that lamp come to life. This led to one of his short student films, *Lady and the Lamp* – which just goes to show how important those early student films are! On graduation John joined The Walt Disney Company as a 'jungle cruise' skipper at Disneyland. In the picture he is telling a TV presenter some of the crazy things that happened in that job. He later obtained a post as an animator at Walt Disney Feature Animation. Blown away by *Tron*, he tried to pass on his vision of CGI as the way ahead to his bosses at Disney, but to no avail. So eventually he co-founded Pixar, which became so successful that it was bought by Disney, and the rest is history!

'I've learnt to trust our gut.
If it feels right we just go with it.'
John Lasseter

Starting out with 3D CGI

In 1992, when it was still in its infancy, I had a little go at using a piece of 3D software and I managed to build a simple lumpy figure. Happily, at about the same time I met the designer and lecturer Andy Laverick, who was just a natural thinker in 3D. So whenever a 3D job came up I passed it to him. As a result I never actually got the hang of it myself, as Andy was just so good with it that I didn't need too. That's why I've asked him to write the following introduction to the wonderful world of 3D CGI.

The most important lesson I could give anyone as they enter the (virtual) world of 3D computer animation is this: 3D computer software is like a pencil; a very clever pencil, I admit, but it should only be used as a medium to allow you to express your ideas, not as a showcase for the software's capability. Start with a simple 3D package – in my experience they all work pretty much the same way, the only difference being the level of detail you can attain in the following main areas.

Stage 1: Modelling

The screen layout is usually broken down into four viewpoints: The top, side and front views (the orthographic views), and the perspective view. Basic shapes are called 'primitives', in this case a cube drawn on screen in 'wireframe'.

Orthographic views used to create and manipulate.

Perspective view, looking at the object as in real life.

Stage 2: Texture

Here our cube has a picture of a brick wall applied, or mapped, to its sides. Some software will allow you to modify almost all aspects of the picture, e.g. scale, orientation, repeat, colour, bump map, opacity (the mortar could be transparent). As with modelling objects, almost anything is possible.

Photo of bricks mapped to the cube.

'Bump map' applied to the surface.

Stage 3: Animating

Start by animating simple movement, e.g. a cube moving from one side of the screen to the other (when I first did this nearly 20 years ago, it was a real 'wow' moment). Change the speed by increasing or decreasing the number of frames between key frames.

Key frame at start and end of action.　　　Some extra key frames added.

Stage 4: Lights, cameras

Lighting makes a huge difference to atmosphere and mood Experiment with intensity and colour. Repositioning the 'camera', i.e. the angle from which the whole scene is viewed, can make a dramatic difference too!

Strong side light applied.　　　Same lighting effect, different 'camera'.

Stage 5: Action!

It's simple to build a shiny spaceship and fly it through a background of stars – the software makes it easy. But making an object move convincingly, giving it weight, creating a realistic bounce, giving a cube a personality – now that is worth aiming for!

Most of all, play and have fun. I have for 20 years, and I still love what I do.

Annabelle Hoggard and 3D CGI

Another excellent 3D animator I know is Annabelle Hoggard, a student at the University of Sunderland. Her work has a personal style – this is not always the case with 3D CGI! – and her progression over the three-year course was staggering. I asked her a few questions about her evolution as a 3D animator, and these are her answers.

SG: What was the hardest part for you in making this 3D movie? What were you happy with and what were you not so sure of?

AH: As my first attempt at animating in 3D, this was all quite a challenge! Finding my way around the program was initially very confusing, and painting the weights on the skin so that it moves properly with the skeleton was very tricky at first. I was just happy that my character moved! It's such an exciting thing that never wears off. At the time I was very pleased with the film, knowing that I would improve on the problems as I practised more.

SG: What was the story behind Robotto, your next film? What were the main things that you discovered when making it? Can you say why you wanted to make it at all?

AH: A clumsy cleaning robot tries to redeem himself by tidying the basement – with disastrous results! Through making this film I got a better grip on modelling shapes, as the whole robot is made up from household items like kettles and a guitar amp. The brief was to create a robot and animate a series of actions. I aimed to get more of a story and character in there instead of just doing the basics. This made it a lot more enjoyable to do and hopefully to watch!

SG: Your BA final piece shows a huge step forward in lighting and poetic movement. What was the best thing about it for you and what were the main lessons learnt?

AH: **Theatre of the Absurd** *is an animation inspired by Plato's theory of forms, exploring the fallacies behind cultural stereotyping through dance, movement and costume. The best thing about this piece for me was the models – I love the designs, and they're still my favourite models to this day. However, it was my first attempt at really complex skeletal rigs. I was slowed down by the fact that the book I was working from was actually wrong, so watch out for errors in your source material! However, having to fix problems myself in this piece really helped me to learn the way rigs work.*

SG: For your MA you chose to explore language communication. What for you is the strength of using 3D CGI in such a project?

AH: **Animated Languages** *is an animated teaching aid for EFL (English as a foreign language) classes. Following the adventures of Anne, Sean and Freya, students log into and explore a virtual world. The 3D animation here has a great strength, being designed to look similar to online games. These have a strong appeal for most young people, so hopefully the design will help keep their attention whilst they are learning. Being a fan of online games myself, it was also great fun to create this in 3D!*

20 Animation in the 21st century

Animation in the 21st century

Throughout the book David Williams and I have chosen key events that have helped animation evolve a step further. These events have mainly been technical discoveries or the creation of new styles. It is far easier to judge key events in the past than those happening now. Hindsight is extremely useful in separating what has turned out to be important from what has not, even though it seemed to be so at the time! The huge volume of animation now available is a 'key event' in itself. So maybe the most useful thing I can do, from a historical perspective, is to highlight the main, currently popular styles of animation, and to give my assessment of where they seem to me to have visually evolved from. This in turn may give you clues as to where they might go!

The highly animated Dixi will now leap to her paws and assist us!

Anime, the cute kind, as typified by the hugely popular Pokémon or pocket monsters. Once again these characters have their roots in Disney, who was famed for his lovable animals. This style can also be tracked back to Felix the Cat, and let's not forget Gertie the Dinosaur (see pages 48–49), probably the world's first, rather large 'pocket monster'.

Here Dixi has changed into a typical anime heroine, with her visual roots in Disney's Snow White, the first well-known animated figure to be based on realistic human proportions. Disney artists often rotoscoped from live action, while Lotte Reiniger (see pages 72–73) made cut-outs in similar elegant proportions. Hard on their heels are some Muybridge (see pages 36–41) cats, who set the initial pattern for 'realistic action'.

3D CGI, often dramatic and fantasy-based. Powerfully realistic, with the addition of loads of special effects. Superheroes, whether mechanical Transformers or part-cat/bat humans, are usually the main attraction. The style has its roots in American comic books such as Superman, who first emerged in 1932. However, the athletes of Ancient Greece were the superheroes of their day (400 BC), so it's open to discussion whether or not they were the prime source!

3D CGI for younger viewers. Simpler forms with scripts often based on fairy stories or classic children's tales. Here Dixi has morphed into *Shrek*'s Puss in Boots, whilst Donkey looks back to his ancestor Muffin the Mule. Similarly, a computer-generated Dougal is observed by his original stop-motion model from *The Magic Roundabout*. Mr Punch, one of the first three-dimensional puppets, looks on and wonders 'What next?'

A flat, 'cut-out' style mainly generated by computers but resembling simple cel or cut-out techniques, e.g., *Southpark* and *The Simpsons*, both of which rely heavily on sharp, witty, 'cool' scripts for adults. Hanna-Barbera produced a host of fast-talking 2D characters in the 1970s, and the same characteristics can be traced back to earlier comic-book characters like Korky the Cat and, of course, Dennis the Menace!

Happily, less commercial animation, such as that produced in Russia, is becoming more widely known. There is also an increasing number of independent animators, with their own original contribution to make to the ever-changing world of animation – maybe you could be one of them!

Animation in the 21st century

So a wide range of animation styles is currently being pursued, and the uses animation can be put to as well as the media on which it can be viewed have hugely increased. There follows a rough timeline indicating when the main modern inventions that utilise animation in some way were first in general use. As this book is being published in 2009, I've used that as my end date and stepped backwards in time!

1939
Cinema was the only way for the general public to view animation – mainly as shorts, but with a few features.

1949
Home cinema was now just affordable – shot and screened on 8, 9.5 or 16 mm film.

1959
Television used animation in commercials for the first time in 1955 for a Murray Mints ad (remember 'Too good to hurry'?).

1969
U-matic ¾ in. tape is the standard in the industry. There was still no viable home video system.

1979
Betamax and VHS (Video Home System) format tapes are now used for both recording and playing back in the home.

1989
Computers get animated. Interactive CDs are available for education and games, as are mobile phones for those who can afford them.

1999
Dial-up internet access for all. Web design becoming a fast-growing industry for animation.

2009
Broadband has long since outstripped Dial-up in speed and number of users. DVD has replaced videotape. Animation is in great demand for sat-nav screens and physically interactive games.

Most of these communication tools can be now accessed on a single mobile phone!

I have not tried to show when all these inventions were first thought of. I leave that to you to research on your mobile phone – using broadband!

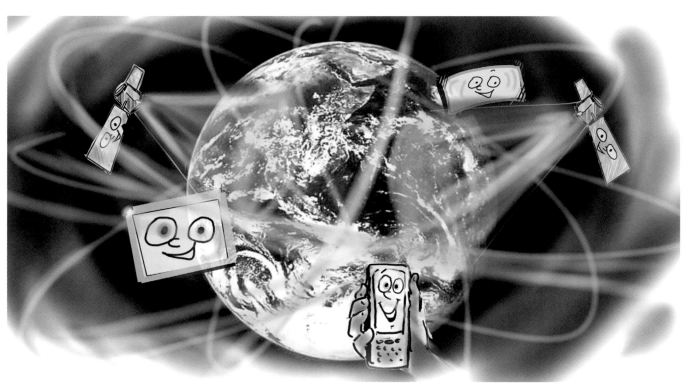

Paul Simon's lyrics for 'The Boy in the Bubble', written over 20 years ago.

'*These are the days of lasers in the jungle,*
Lasers in the jungle somewhere,
Staccato signals of constant information,
A loose affiliation of millionaires
And billionaires, and baby,
These are the days of miracle and wonder,
This is the long-distance call,
The way the camera follows us in slo-mo,
The way we look to us all, oh yeah,
The way we look to a distant constellation
That's dying in a corner of the sky,
These are the days of miracle and wonder
And don't cry, baby, don't cry,
Don't cry, don't cry.'

Animation in the 21st century

We have ever-increasing ways to create animation and ever-increasing ways to communicate what we create. The final question is 'What is it you want to say?'

Only you can decide. In a way my choice was decided for me shortly after I had started playing with animation just for fun. In 1972 a Schools Council project on the 'practice of audiovisual language and learning' enabled me to turn the 'animation club' I was running after school into a cross-curriculum project. A 14-year-old girl was sitting at one of the small homemade lightboxes we were using, looking at a diagram in her biology textbook of a heart and its related blood vessels. 'I can't get the blood to go through the heart properly,' she said. Sure enough, it was impossible to animate a continual flow. When the specialist biology teacher looked at the book he said, 'There's a valve missing – I've drawn that diagram on the board for 20 years and never noticed.'

The student's heart.

A heart from our CD-ROM.

It struck me at that moment that animation was as effective as open-heart surgery for discovering how normally invisible processes worked – and with far less blood! Secondly, the huge motivation of the youngsters throughout the project showed me that 'if it moved' they wanted to make it and watch it!

Since then I've followed two main paths. One has been encouraging others to make their own animation in their own way – whether that be to learn, for self-expression or for fun. As my Aunty Mabel said, 'It's important to have something to pass the time.' She lived to be 102, so I guess she knew about these things!

The other path has been to create material to encourage others to learn, such as the heart above on one of many interactive CD-ROMs produced by Sheila Graber Animation Ltd. Now that I'm semi-retired, my aim is to pursue animation as a way of explaining systems, whether natural or manmade. It'll help pass the time.

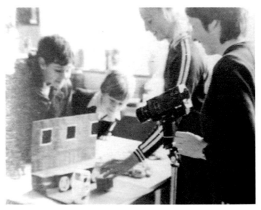

School children in 1972, using a Super 8 camera for animating.

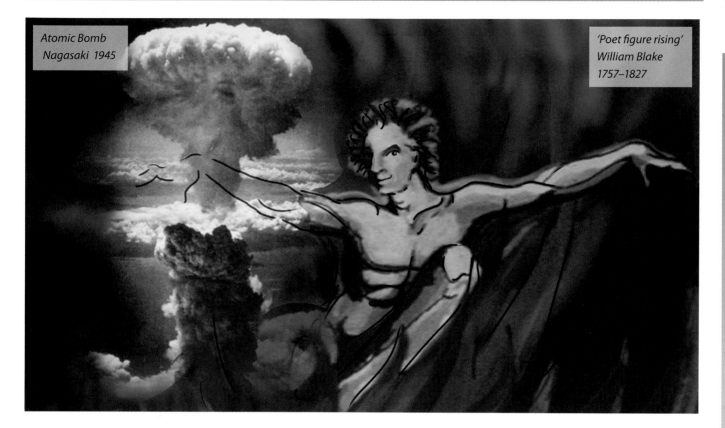

Atomic Bomb
Nagasaki 1945

'Poet figure rising'
William Blake
1757–1827

If we say a person or a movie is 'animated', we know there will be energy involved.
So we could sum up the whole process by saying that Animation = Energy.

There are a couple of other equations related to energy that are worth considering. Albert Einstein, the famous theoretical physicist, saw energy as $E=mc^2$ (energy equalling the mass of an object times the speed of light squared). From this emerged the use of atomic energy as a force for good or evil. Compare this with Blake's 'Energy is eternal delight' (which it can be if used in a positive way) and we're back at where we started this book: 'Whether you use that energy to create or destroy, it's the same energy.' Let's hope creation wins!

Disney reckoned animation was 'the art of the future'. Who knows if he was right? I learnt from my Mother that maybe we can't really predict the future. I remember her telling me that in 1910, when she was nine years old, people were genuinely concerned that the whole world would be engulfed in horse dung. She said crossing the road at that time, when horses were the main mode of transport, was a major problem. Suddenly out of nowhere came the motor car, and one problem was solved, while another was created that is yet to be solved.

So no predictions from me. But whatever the future holds for us all, I hope it's bright and highly animated!

Biographic History of the work of Sheila Graber

As people have checked over the manuscript they said that it reads as a 'life story'. This was not my intention whilst planning the book, but looking back on it I see that this is indeed how it has evolved. Here are some self portraits created at key stages in my life which might help explain the development of my thinking and animation.

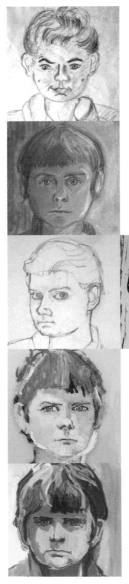

Age 11 This was a portrait drawing in pencil for art homework.

I can remember drawing my moles with great precision and showing the fact that I can raise my left eyebrow.

Age 15 Pastel portrait drawn at home. Starting to explore light and shade. Note the moles have disappeared, even though they were, and still are, there in real life.

Age 17 Studied Fine Art at Sunderland Art College. Taught to look for 'the spaces in between', I explore pencil, woodcut and pen & ink.

Age 21 Oil on paper portrait. After completing the 'National Diploma in Design' I went on to the 'School for Training Art Teachers' at Birmingham. Here I met Mrs Burroughs and the concept of 'everyone being an artist in their own way'.

Age 23 My Dad died from cancer of the lungs and I started smoking! I remember him writing in my autograph book when I was about 8 or 9 'To your own self be true'. I never understood his words until much later, but once I did, I tried to stick by them.

Age 25 I married a sea Captain. Two pencil drawings I did in my cabin mirror. Age 30 divorced, I painted this dry brush on paper portrait. I also start exploring animation.

Age 45 Oil on paper portrait done for a one woman show at the Durham Light Infantry Museum & Arts Centre. This displayed a wide selection of paintings and animated films done to date.

Age 51 My Mother died suddenly from a heart attack mid-crotchet. Her last words were 'Get on with your work'. I gradually lost myself in animating, painting and cats.

Age 56 Having explored computers since I was 50 I was at last able to draw this self portrait, via a graphics tablet, straight into the computer. That year Sheila Graber Animation Limited was founded with fellow director and business manager Jen Miller.

Age 65 Oil on canvas, painted for a one-woman retrospective show of my painting and animations at the Customs House South Shields. Prior to my leaving to live in Southern Ireland.

I keep all my art work in a big heap. As I sorted through, one portrait jumped out at me. "What a gloomy looking face", I thought, then slowly worked out that it was done when I was 23 after my Dad died. I would recommend that you date everything NOW. It will help a lot to see how you've evolved when you get to 68 and beyond!

Glossary

Many of the following words have multiple and more complex meanings. I have given definitions that apply to the particular emphasis I have given them in this book.

A and B rolling
Two reels of film are laid in parallel on the editing bench. Starting with the 'A' roll, alternate scenes are placed in the required position – scene 1: A roll; scene 2: b roll; scene 3: a roll, and so on – with strips of black leader in between. Through this technique mixes and clean edits can be made. This is where the A and B channels originated on computer-editing software.

Analogue animation
Any form of image which is created by hand without using a computer.

Animatic
Animatic is a series of still images edited together and displayed in sequence. More commonly, a rough dialogue and/or rough soundtrack is added to the sequence of still images (usually taken from a storyboard) to test whether the sound and images are working effectively together.

Animation rostrum
A specialised piece of equipment which holds the camera steady over the artwork. Lights are set at a special angle to avoid reflections on the glass panel, or platen, which keeps the artwork flat.

Animated Gifs
A compressed form of movie which will run easily on computers and is often used on websites. Introduced by CompuServe in 1987.

Animation
The art of creating life where none existed before.

Armature
A framework around which a sculpture is built. When this technique is used in computer 3D software, it is called a skeletal rig.

Bit-mapped image
A computer image that is stored and displayed as a set of coloured points in a rectangular grid. Also called a raster graphic.

B/G
A media-shortened term for background.

Cel
Short for celluloid, the material from which the first transparent sheets, used for animating on several levels, were made. It was later replaced by sturdier celluloid-acetate plastic.

CD-ROM
Compact Disc Read-Only Memory. This means it can be read but not written to.

CGI
Computer Generated Image. This can be two-dimensional and often drawn using a graphics tablet plugged into the computer; or three-dimensional, usually created by the manipulation of specialised software to create a virtual world.

Cut-out animation
Cut paper shapes moved around with stop-motion technique under a glass platen. The kinds of effects achieved by animators using this technique ranges from jerky to poetic.

Digital animation
Any form of image which is created via a computer.

Doubles
One second of time on screen is usually classed as 25 (or 24) frames of animation. For very smooth action it is usual to draw one new image for every frame. To halve the work and still maintain good animation one can draw only 12 images and shoot 2 frames of each.

Film, 16 mm and Super 8 mm
16 mm was a motion-picture film format introduced in 1923 by Eastman Kodak as an inexpensive amateur alternative to 35 mm film. In 1965 the same company introduced the smaller, cheaper Super 8 film format.

Graphics tablet
A computer input device that allows images and graphics to be hand-drawn, similar to drawing conventionally with a pencil on paper.

Light box

A box with a sheet of translucent acetate or glass with a small cool light shining underneath. A sheet of paper is punched and placed over peg bars attached to the light box, and a drawing is made. When a second piece of paper is placed over the pegs in register, it is possible to view the drawing beneath and thus easily trace over it or make small changes.

Manga

A Japanese word meaning 'whimsical drawings', the term was first used by Hokusai (1760–1849).

Morphing

A special effect in animation that seamlessly changes one image into another.

Multiplane camera

Usually one glass-covered platen is used to hold the artwork in place for shooting. In 1926 Lotte Reiniger first used a series of platens stacked vertically to add to the depth and movement of the animation. In 1933 Disney further developed this technique.

Peg-bar registration

Drawn animation needs each image to be registered with others to prevent them slipping. When drawing and filming or scanning, each sheet is hole-punched and the holes fit over a peg bar fitted to the light box and platen or scanner. The animation industry normally used three pegs on an Acme punch and peg-bar system. However, it is possible to use a much cheaper two-holed office punch that does the same job.

Pikachoo

One of a series of fictional Pokemon creatures, AKA Pocket Monsters.

Pixillation

Shooting live action via film or digital movie camera using a limited number of frames. The fewer the number of frames per second, the faster the action becomes.

Platen

The hinged glass plate that when lowered on top of several layers of artwork keeps it all flat in order to take a frame of animation.

Quick Time

A multimedia framework developed by Apple Inc. for many purposes, one of which is allowing movies to be run on a computer.